ONE HUNDRED PHOTOGRAPHS

A COLLECTION BY BRUCE BERNARD

COMMENTARIES AND AFTERWORD BY MARK HAWORTH-BOOTH

Three years ago, through a series of fortunate, friendly personal contacts,
I was offered the part-time occupation of making a collection of photographs.
This was for someone who, while already a collector of paintings and the plastic
arts, wanted to come to closer grips with the photograph, and could afford this
now very expensive, but, I would hope, thoroughly satisfying way of doing it.
Before circumstances cut down many further forays into auction houses and art
fairs all over the place, I persevered with considerable pleasure, visiting them
in New York and London as well as in Basle, Paris etc. – all the time meeting
and being solicited by the so often good fellowship of dealers – and frequently
finding rare images that I considered worthy of inclusion in my rather
unpredictable hoard of basically serious booty, while of course often feeling
deeply frustrated by being beaten at the bidding and by the unavailability of
many beautiful things.

I wanted to include every kind of photograph that truly stimulated and satisfied
me, and that it seemed could permanently continue to do so. And, as I hope
can be seen here, have found some of the magic of the medium – its uncanny
life-preserving qualities and unique perceptions – from the great figures of the
nineteenth century to the often rather wonderful snapshots perpetrated in the
first half of the twentieth century by amateurs, to the special genius of André
Kertész (I think Henri Cartier-Bresson's is only very rarely suitable for
collection) as well as the intrepid and often impassioned photo-reportage of
Don McCullin and many others. Nothing, as can soon be seen, has been barred.
Though my first and keenest interest has always been in painting, I fell heavily
for the photographs in *Picture Post* and *Lilliput* magazines during my early teens.
These seemed to tell of a real life far from the kind of homes and schools I
was obliged to live and learn in, and my earliest interest in sex – as with many
British adolescents – must have been stimulated to some extent by *Lilliput*
in particular.

I never much wanted to take photographs myself but I did try out a Box-
Brownie birthday present. Soon, however, I became much more absorbed in
my interest in painting and didn't look very seriously at photographs for many
years, when by a series of odd chances and a suddenly growing enthusiasm,
I became picture editor of the part-work or serial magazine *History of the 20th
Century* and then quite soon of the *Sunday Times Magazine*. Here I researched and
edited a series called 'Photodiscovery', which was developed into a book seeking
to define the new wave of interest in the photograph then sweeping the United
States and to a lesser extent France and Great Britain. I was certainly hooked
and gratefully so – as were thousands of others, those who could buy them and
those who could only enjoy looking. I can only hope that the character of this
little collection, which I don't like to think of as over modest, tells of
unsuspected and entirely natural depths in the often surprising and gratifying
relationships between the classic and the vernacular strains that are embodied
in it. Apart from certain unspeakable levels of photography, it all seems much
more equal to me than when I started, and I would, with the great Sam
Wagstaff, willingly show a Cameron, say, with a really distinguished anonymous
postcard (ultimate judgements of course reserved). My upper limits of
expenditure can clearly be seen in this selection, not because of any parsimony
involved, but owing to something like an insanity which has descended on the
photographic market, where a nice enough Imogen Cunningham (not unique) is
reckoned equal to a good small Rembrandt drawing.

January 2000

Edward S. Curtis (1868–1952)
Nature's Mirror – Navajo (1904)
Toned gelatin-silver print
Signed in pencil on mount
Lettered in plate: *Copyright 1904 By E.S. Curtis *987*
Mounted on coloured papers

Curtis was a successful portrait and landscape photographer
before beginning an extraordinary venture – supported by
President Theodore Roosevelt and the banker J. Pierpont
Morgan. *The North American Indian* was published between 1907
and 1930, comprising twenty volumes of text with 1,500 full-
page illustrations, and a further twenty volumes of photogravure
prints like this. Curtis did more than anyone to preserve 'the
vanishing race' in words and images, including a film (*In
the Land of the Head-hunters*, 1914). He funded the enterprise in
the 1920s by working in Hollywood. His photographs include
documentary evidence and theatrical spectacle. Here he has
made an image which links Navajo piety to one of the
underlying themes of the medium he was using – that
photography is a natural reflection.

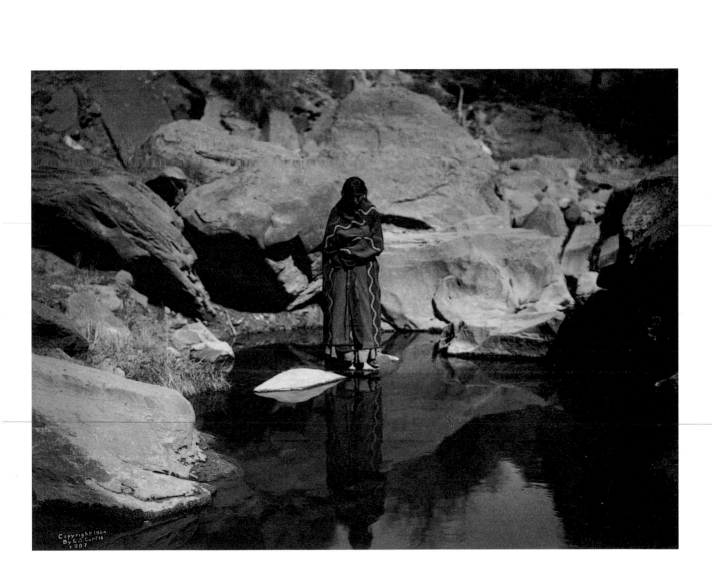

2
David King (b.1943)
Muhammad Ali (1974)
Gelatin-silver print

King photographed Ali at his training camp in Deer Lake,
Pennsylvania. Ali was preparing for Superfight II with Joe Frazier
at Madison Square Garden. Between rounds of shadow-boxing,
Ali's masseur, the Cuban Louis Seria – the man who knew
his physical condition better than Ali himself – would rub him
down. Bruce Bernard, who knew this photograph from soon
after it was taken, as he and King were colleagues at the
Sunday Times Magazine, wrote that Seria's 'gnarled old hand
with its slight movement blur is one of the greatest hands in
all photography'.

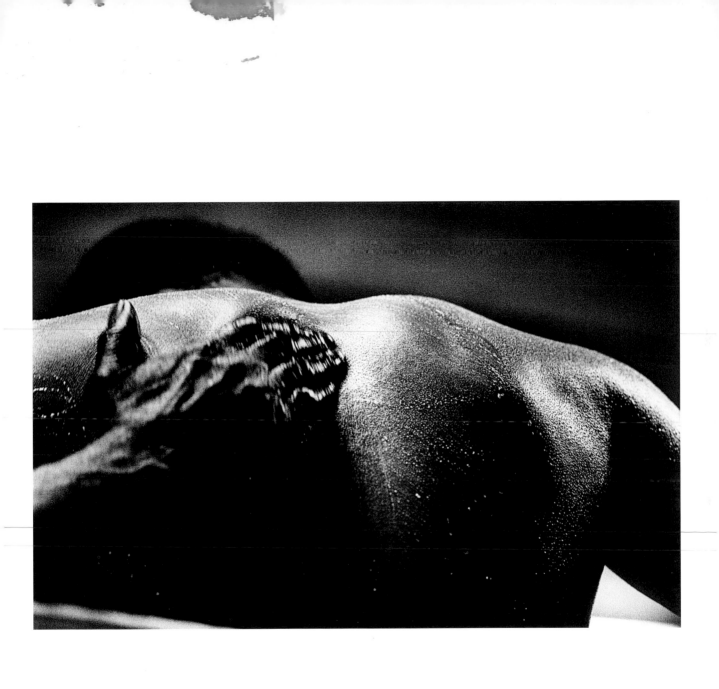

3
Graham Smith (b.1947)
Sandy and Friend, South Bank (1983)
Gelatin-silver print

Inscribed in pencil on verso: *Sandy Venice is in the 'Commercial'*
pub with Elsie early afternoon. We were drinking from pub's opening
that morning. Sandy got a black eye the night before getting my
cameras back (look at his knuckles). I used to buy him a beer for
looking after me and my cameras when I got into a state. We
were all in a state the night before – good days. Graham Smith
This belongs in a tradition of bar photography stretching
back through Weegee to Brandt and Brassaï. The couple
here seem more ordinary than their predecessors but are
seen more tenderly.

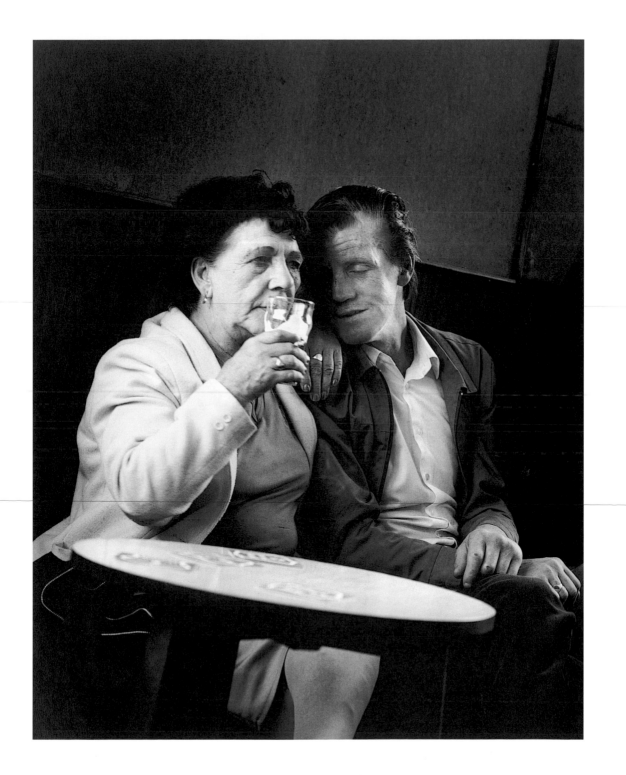

4
Anon
Untitled [Cheesecake] (c.1940)
Gelatin-silver prints

'Photography', wrote Lady Eastlake in 1857, 'has become a household word and a household want; is used alike by art and science, by love, business and justice; is found in the most sumptuous saloon, and in the dingiest attic – in the solitude of the Highland cottage, and in the glare of the London gin palace ...' It was also placed furtively in wallets: the new medium was harnessed to the pornography industry from the 1850s onwards. This episode in three frames, made before the advent of phone-sex, is surely among the most innocent examples of the genre.

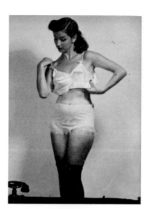

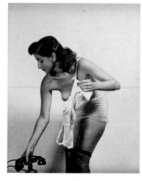

5
Anon
Untitled [Children's Nursery] (1905)
Gelatin-silver print

Blur is among the characteristic visual properties of photography.
It entered the repertoire of professional photography, as a means
of indicating rapid movement, by 1860. However, blur is best-
known as a familiar feature of amateur photography, in which
hope and enthusiasm attempt to compensate for limited
equipment or technique. Here an Edwardian parent perfectly
captures a daughter's bedroom, with its neat calendar, muslin
hangings, cane-backed rocker, dolls, rabbit, picture book, and
the child's wildly spinning head – which sprouts a riot of ferns.

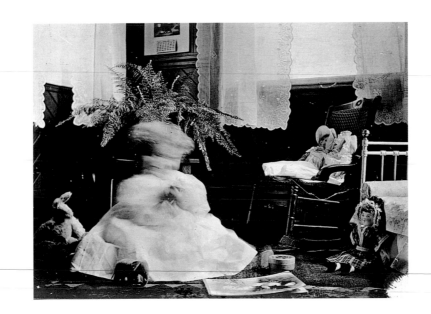

6
Eugène Atget (1857–1927)
La Monnaie, Quai Conti, Paris (1905–6)
Albumen-silver print

Atget, who advertised his business as providing documents for
artists, is the master of photographic fact but also of evidence.
This picture is like a diagram, which a viewer can enter, and
simultaneously interpret: standing on the helpfully provided
stone slab to twiddle the tap and fill the stone basin. We note
that, after use, the water drains away from the base and through
the grille at the left. If the stone basin was used for washing,
the wooden vessel by its side is presumably for rinsing.
Whatever the details, we leave the photograph with rinsed eyes.

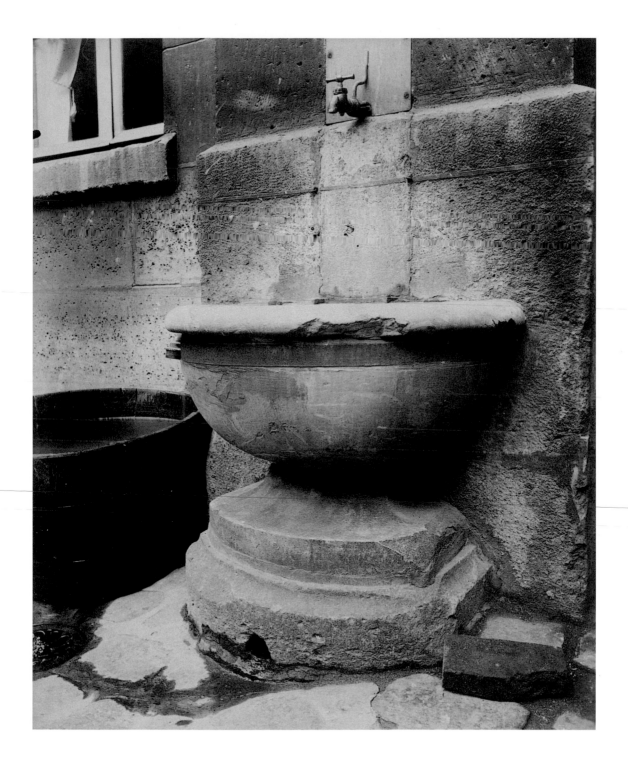

7
Felice Beato (c.1834–c.1905)
A Yokohama Beauty in the Snow (c.1868)
Albumen-silver print and watercolour

Beato, the foremost Victorian war photographer, settled in
Yokohama in 1864. He was among the first wave of Westerners
to arrive after Japan opened itself to the West in 1859. He
published two superb volumes of photographs in 1868, one on
Japanese landscape, the other on Japanese life and customs. His
customers – initially the military, naval and merchant contingent
in Yokohama – could buy his photographs loose or in albums.
Local artists were trained to hand-paint the photographs of
costumes and customs sometimes with a subtlety that borders
on invisibility.

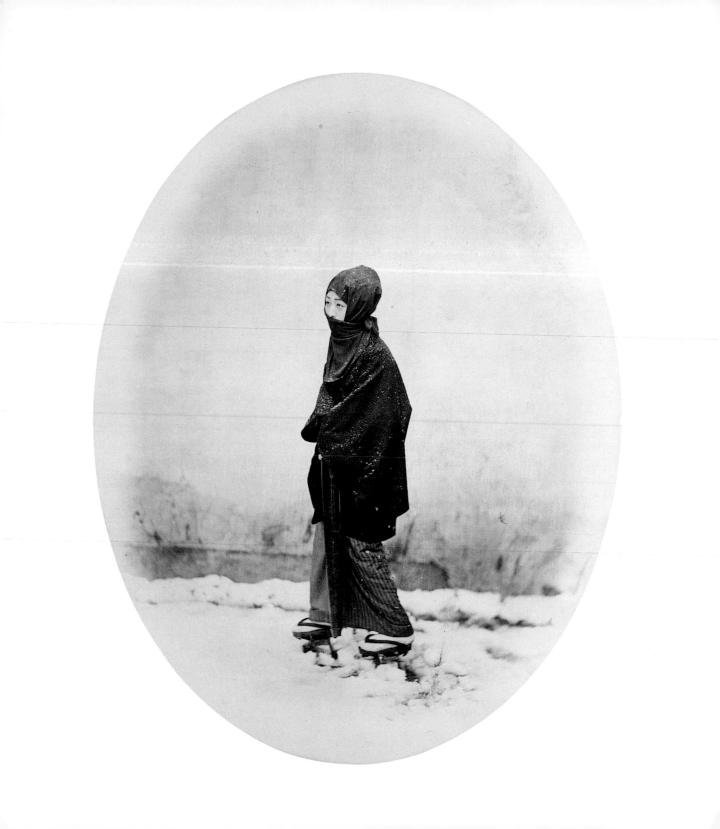

8
Anon
Dahlias (c.1860)
Albumen-silver print

Photographs of plant forms were offered as inspiration to textile
designers, replacing – for example – lithographs of Dutch still-
life paintings. Although such photographs were presented as aids
for pattern-designers, they were exhibited in important
exhibitions in the 1850s and 1860s which were heavily visited
and widely reviewed. The unknown, probably French,
photographer of these dahlias not only described the blooms
exquisitely but eschewed conventional composition and suggested
evanescence as a passing breeze blurred some of the leaves.

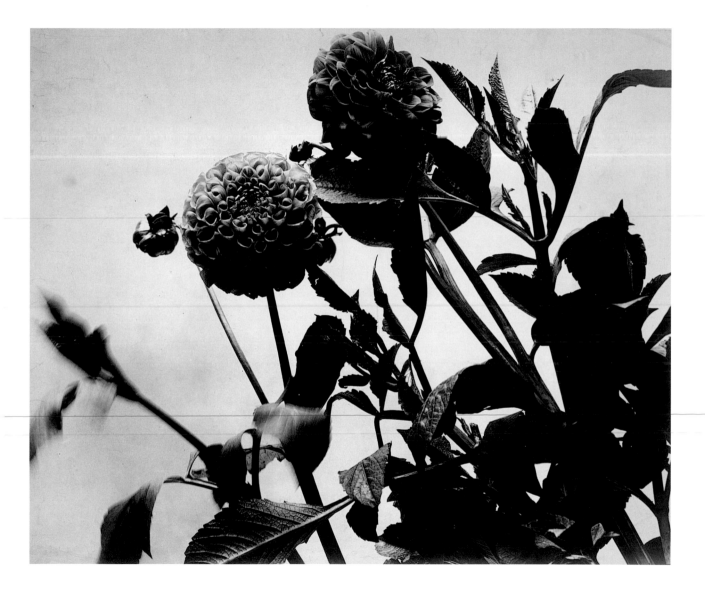

9
Stéphane Geoffray (1830–81)
Vénus de Milo (1858)
Paper negative (waxed)

The most famous sculpture in the world – at least until the
Statue of Liberty came along – meets photography, in the form
of a small negative made on ordinary writing paper. Negatives
were chemically developed, which produced an image in black
and white. From this modest source thousands of prints could
be made, thus spreading the fame of the Venus de Milo even
further, and making authentic facsimiles available everywhere.
The dreams of early photographers and their publishers were
not so different from the creators of today's websites.

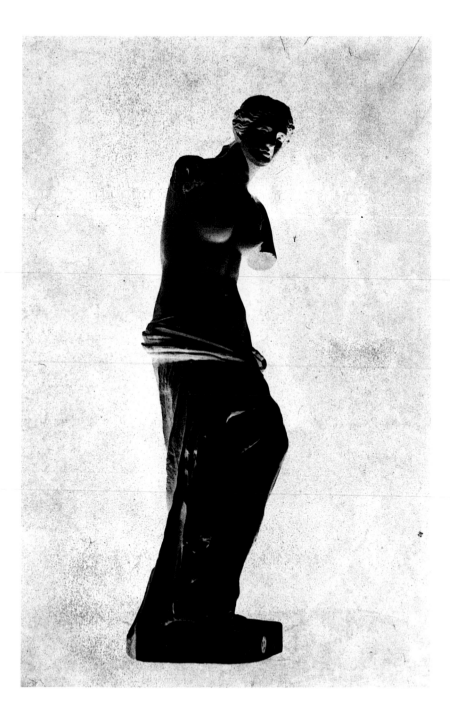

10
David Wise (1959–99)
Girl in Hartlepool Pub (1986)
Gelatin-silver print

David Wise, greatly influenced by the work of Graham Smith,
became a specialist photographer whose forte was the intimate
world of the pub in England's north-east. Bruce Bernard was
drawn to such photographs, just as he was drawn to pubs
themselves, because of the characters they contain, and he
published this and others by David Wise in the *Independent
Magazine* (24 March 1990). The girl's expression and pose
suggest something of the graceful, tough vulnerability seen
in paintings of bars by Manet, Degas and Picasso in his
Blue period.

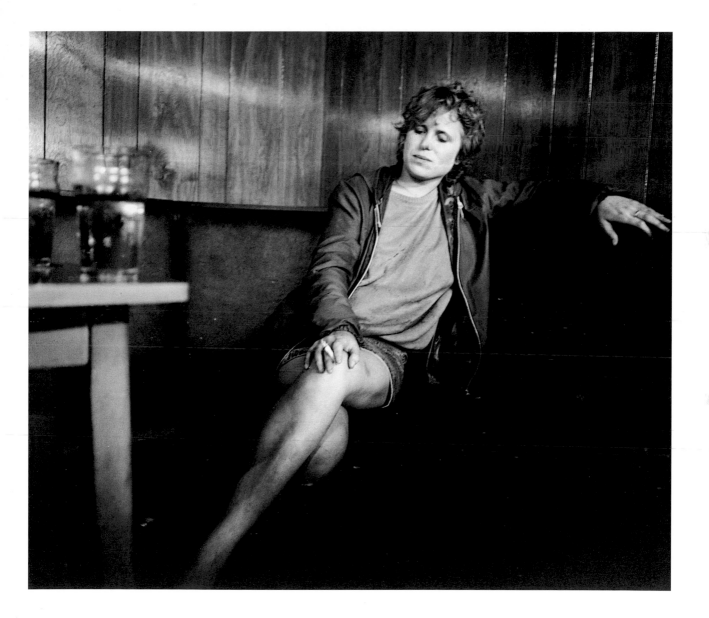

11
Colin Jones (b.1936)
Dockers, Liverpool (1963)
Gelatin-silver print

'The Lump' was the practice by which shipyard-owners chose
dockers each day. Teams of seven gathered at the dock gates
hoping to be picked for work. Jones portrays a true-life British
version of Marlon Brando in *On the Waterfront*. We can see that
he worked with little protection against the accidents of his
dangerous trade – wearing a cloth cap instead of the hard hat
of today – facing rats swarming in the holds, exposure to toxic
cargoes, and the threat of not being selected from 'the Lump'.

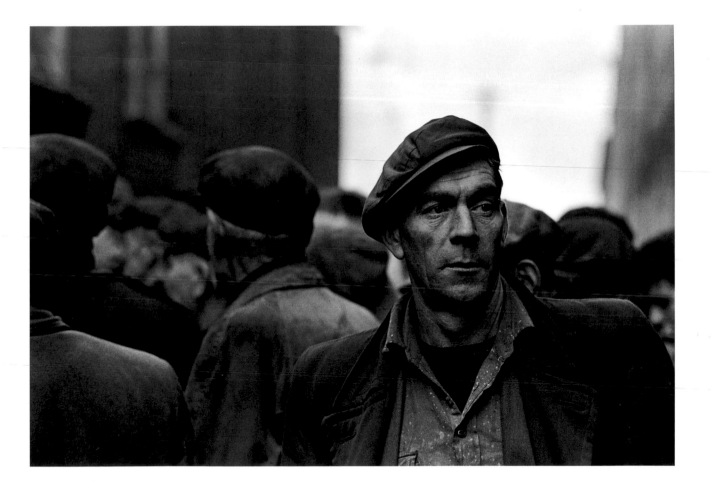

12
Dr Paul Wolff (1887–1951)
Hindenburg Zeppelin (1930)
Gelatin-silver print

Wolff was one of the best-known masters of the Leica camera,
which was introduced in 1925. He lectured, published and
exhibited widely, including a contribution to the defining event
of the New Photography of the 1920s, the *Film und Foto*
exhibition held in Stuttgart in 1929. The light, rapid-action,
highly-engineered Leica camera symbolized the photographer
as an active and universal Modernist figure, as fearless as the
aviator here, seen calmly controlling another (but shorter-lived)
symbol of twentieth-century technological prowess.

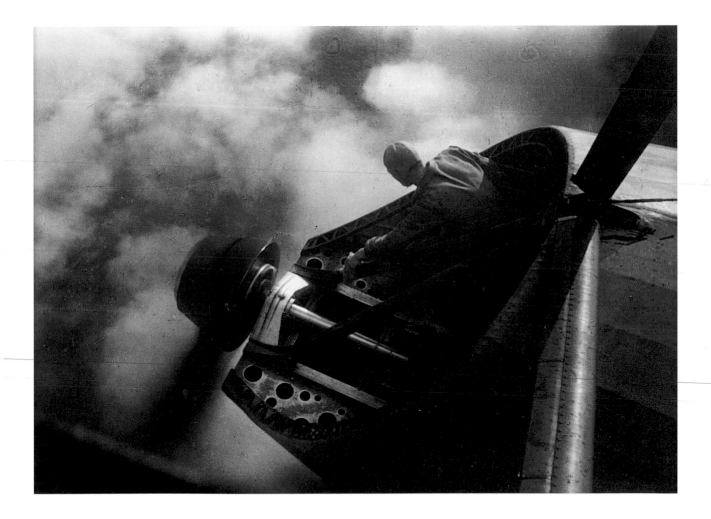

13
Chris Killip (b.1946)
Alice and her Dog (1982)
Gelatin-silver print
Inscribed in pencil on reverse: *For Bruce, Chris Killip, 1989*

Chris Killip, from the Isle of Man, spent six months living and
photographing at a seacoalers' camp at Lynemouth, near
Newcastle in 1982–83. The seacoalers, using horses and carts,
harvest coal from the beaches, where it drifts as waste from
a colliery up the coast. Many of Killip's photographs captured
the harsh conditions, the work and conflicts with the authorities
– but he also photographed more intimate episodes such as this,
in which time in a steamed-up caravan passes slowly and
moments can be cut into the smallest slices.

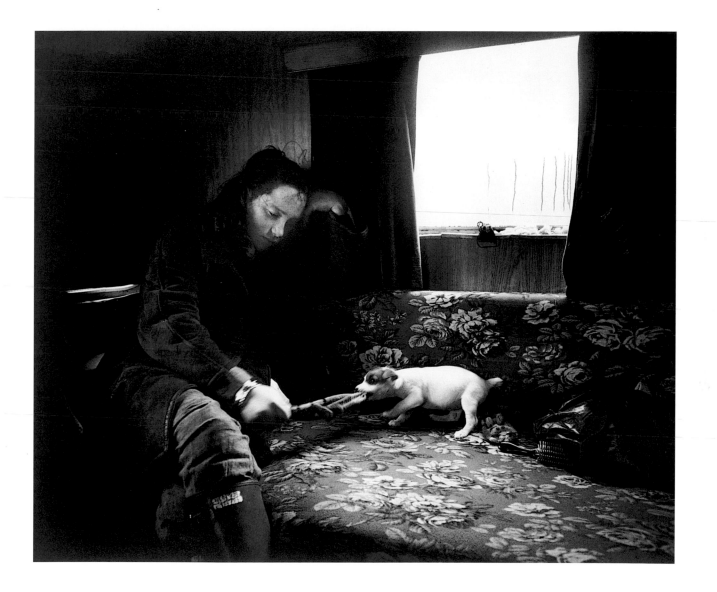

14
Harry Diamond (b.1924)
Duke Ellington (1973)
Gelatin-silver print

Jazz performance has attracted photographers since the 1920s, when faster films, lenses and shutter speeds made the subject possible by available light. The flash-bulb introduced in 1931 gave enhanced opportunities, but many aficionados of the music have preferred to avoid the intrusion of flash – and the Duke would not permit it. Ellington was performing at the Rainbow Theatre, Finsbury Park, London. Harry Diamond, a major fan, photographed a moment when Ellington was dancing in front of the band, conducting with his legs.

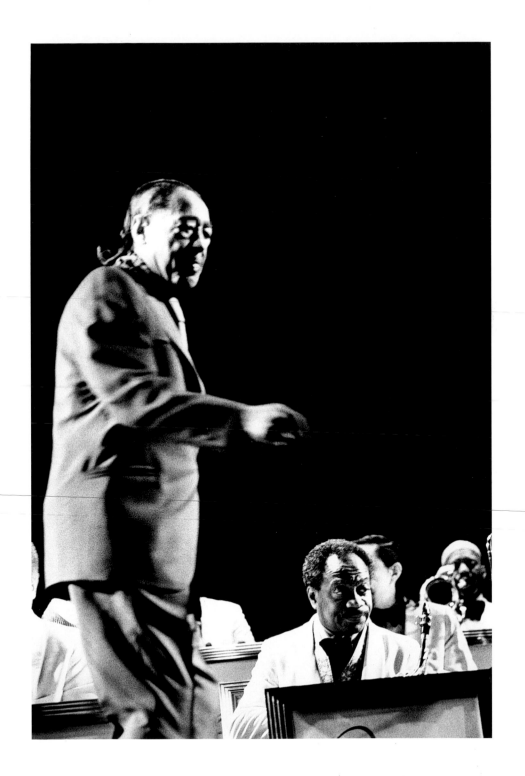

15
Irène Jonas (active c.1960s)
Marine sur la paille (c.1960s)
Postcard of a hand-painted photograph

Although the Germans thought up the plain Korrespondenzkarte,
the picture postcard appears to be a French invention from 1871
and it was the French who created an international postcard
craze which began at the Paris Exhibition of 1889. Their
attraction is that producers often published – and continue to
publish – original or idiosyncratic images. Bruce Bernard found
this one in Dieppe, bought up the stock (of seven) and sent
them to friends in the early 1990s. 'Marinc' is a diminutive of
Marie as well as the word for seascape, which makes waves
of the bales of straw.

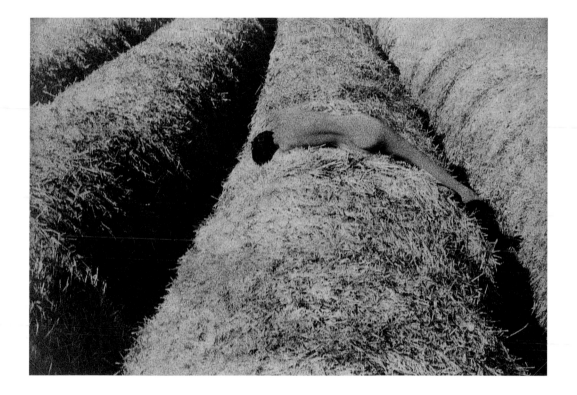

16
Attributed to Bonfils Studio (1867–1930s)
Jewish Woman (c.1870)
Albumen-silver print from glass negative
Inscribed in the negative: *No. 334*

La Maison Bonfils was set up in Beirut by Félix and Lydie
Bonfils, later assisted by their son Adrien, with branches in
Jerusalem and Baalbek. The company specialized in views of
Egypt, Palestine, Syria, Constantinople and Greece – plus a
series on 'Costumes, Scenes and Types'. Because of social
propriety, Madame Bonfils would have photographed female
subjects. Such images would have been received by many of
the company's French customers through the evocations of
the Orient offered by such poets as Gérard de Nerval and
Victor Hugo.

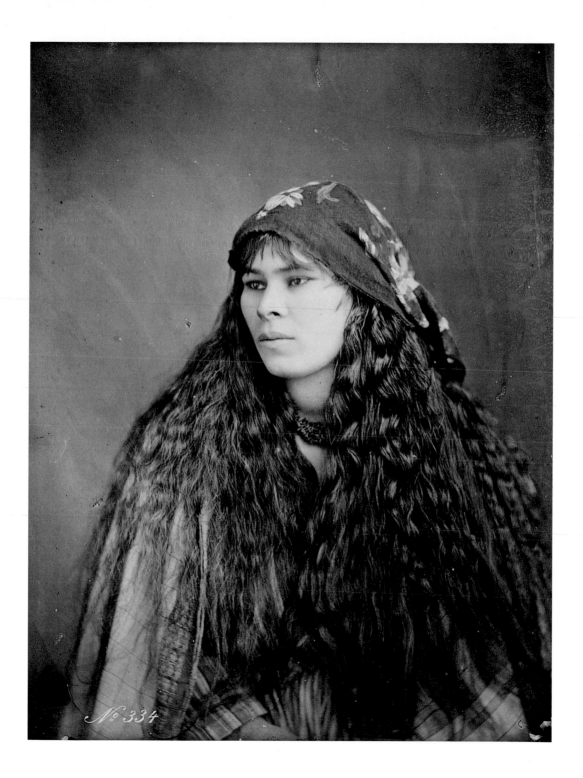

No 334

17
Captain W. W. Hooper (1837–1912)
Wheelwrights, India (c.1870)
Albumen-silver print from glass negative
Inscribed in the negative: *68*

Lord Canning (1812–63), the first Viceroy of India, fostered
photography in India in the 1860s by encouraging army officers
and civilians to assemble collections of photographs depicting life
there. By 1865 the India Office in London had received over
100,000 prints. Eight volumes of *The People of India* were
published (1868–75) containing works by more than fifteen
photographers including Captain Hooper. He made authentic
photographs of everyday customs and trades. Many trades were
– then as now, and conveniently for photographers – carried out
in the street.

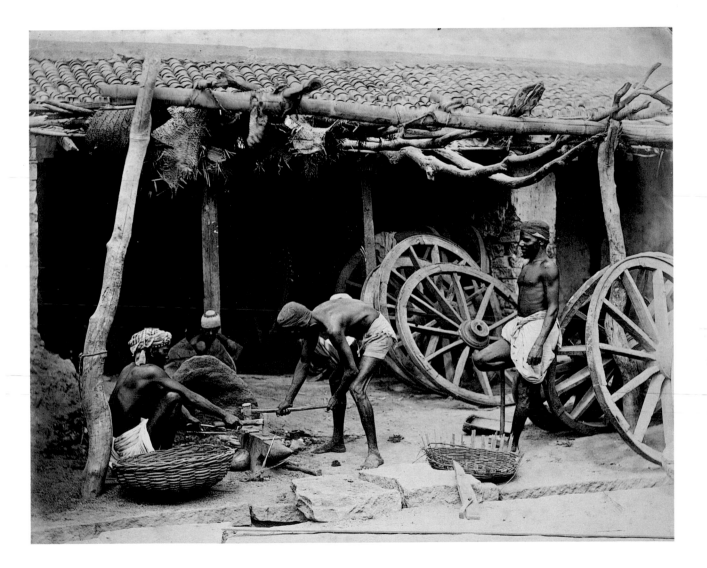

18
Giraudon's artist
Goat-herd with goat, probably near Barbizon (c. 1870)
Albumen-silver print from glass negative
Inscribed in the negative: *B.7*

Auguste Giraudon, a Paris editor and photographic art publisher,
announced in the 1870s that he had commissioned a painter –
who wished to remain anonymous – to take a series of 'artist's
studies'. These were intended to help artists to produce lifelike
representations of light and shade, the human figure, foliage,
etc. The series suggested a close awareness of J. F. Millet's
studies of peasant life in the Forest of Fontainebleau. This
photograph suggests an interest in the way strong sunlight
dissolves forms, anticipating a characteristic effect of
Impressionist painting.

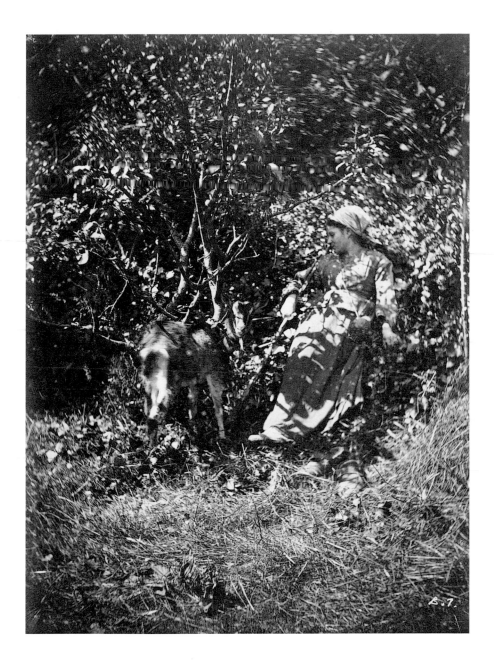

19
Mario Algaze (b.1947)
Espejo, Barroco-Otaualo, Ecuador (1988)
Gelatin-silver print

Algaze emigrated from Cuba to Miami aged thirteen and began
his photographic career at twenty-four. His subject is Latin
America, which he approaches as a fabulist. Here he creates
a story, or ballad, around Indians resting in what might be the
courtyard of an inn. One has a blanket, another a guitar, a
third a baby at the breast. A seated couple wear complementary
clothes – he shining white trousers, she a shining white blouse.
The scene has two special ingredients – a figure who turns on
the stair and an espejo (mirror) which captures everything,
magically, like a camera.

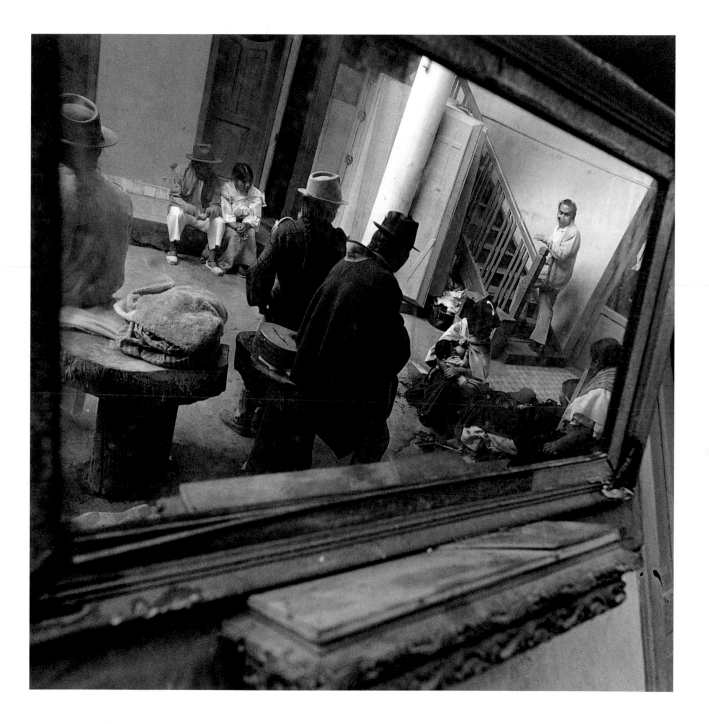

20
Richard Riley (active c.1900)
Negro Wedding at Hampton, Virginia (1897)
Platinum print

Riley photographed at the Hampton Institute, which was set up
in the era of Reconstruction following the American Civil War.
It taught black and American Indian youths vocational skills.
Booker T. Washington, a graduate, wrote of the school in his
autobiography *Up from Slavery* and set up the Tuskegee Institute,
Alabama, where Riley also photographed. The Hampton Student
Singers appeared all over the USA. Riley captured this unusual
subject using open-tray flash and perhaps a variety of 'banquet'
camera designed for photographing large groups.

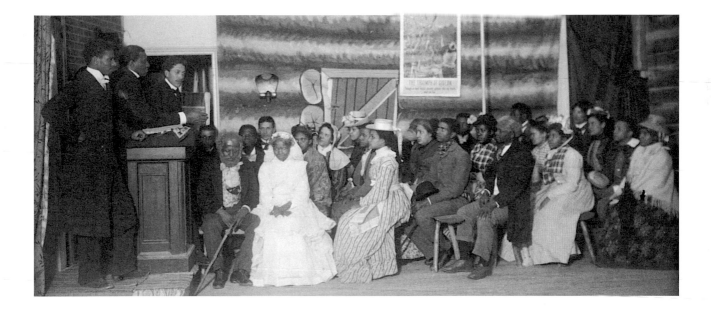

21
A. A. E. Disderi (1819–89)
Monsieur Jules Brame, Député du Nord – Ministre (1867)
Albumen-silver print from wet collodion on glass negative
Titled, dated and inscribed on paper label: 68197

The idea of a miniature photographic portrait that could serve
as a visiting card emerged in Paris in the early 1850s. It was
patented by Disderi in 1854. Ten, six or – as here – four
different poses could be exposed on one glass negative plate.
All of the portraits could be printed, by sunlight, simultaneously,
then trimmed, pasted to card and sold to the client by the
dozen, the score or the hundred. Exchanging them among
friends and acquaintances for compilation into albums was
a widespread pursuit in the late 1850s and 1860s.

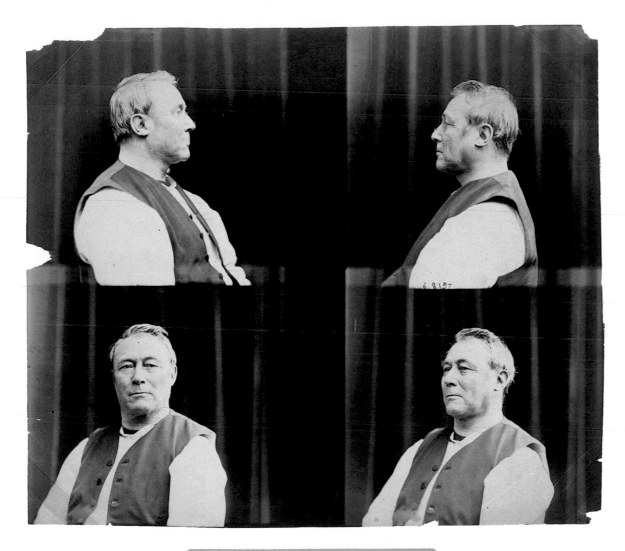

68197. M. Jules Brame 1867
député du nord - ministre

22
A. A. E. Disderi (1819–89)
Untitled [the pet of an unknown client] (c.1865)
Albumen-silver print from wet collodion on glass negative

The *carte de visite* format gave clients, or their pets, the
opportunity to hold the same pose for each of the four or more
exposures, or to vary it. While the politician M. Brame (no. 21)
seemed determined to find his best aspect, the dog appeared
comfortable with one pose, losing interest in the whole process
before the final frame. It is impossible to read such multiple
view photographs now without recalling Andy Warhol's quartets
of identical photographs from the early 1980s or the brilliant
dogs in the *oeuvre* of William Wegman.

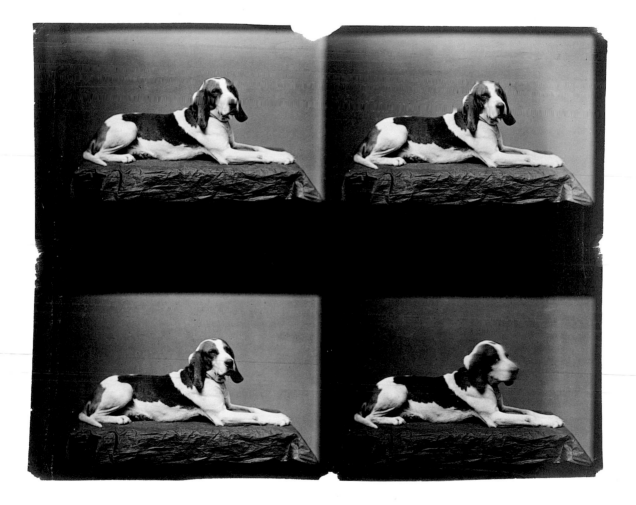

23
Arnold Genthe (1869–1942)
Sarah Bernhardt as Phèdre in the Greek Theatre of Berkeley (1906)
Gelatin-silver print
Typed slip on mount titled: *SARAH BERNHARDT*

Two weeks after the San Francisco Fire of 18 April 1906,
Sarah Bernhardt arrived. She visited the ruins with Genthe, who
thought she looked 'tragically old' in the bright sunlight. He
wondered how she could possibly create the illusion of Phèdre
on the stage of an open-air theatre. The *grande dame* rose to the
occasion: 'Young, vital and magnificent, she gave one of the
great performances of her life' – inspired, she said, by the
audience. 'They felt that I had something to give to make
them forget the loss of their material possessions.'

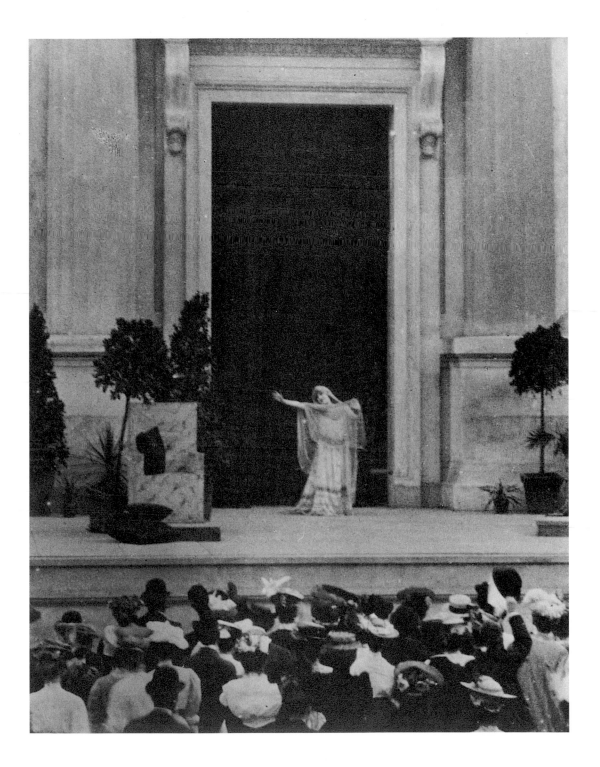

24
Evelyn Hofer (b. c.1925)
Atelier Balthus: Unfinished painting of Le Chat au Miroir II (1989)
Dye transfer print

Bruce Bernard was himself a highly accomplished photographer
of artist's studios, including ones with works in progress on the
easel. Evelyn Hofer is a specialist in colour photography and did
justice to the subtle natural light in Balthus' studio. On the easel
is one of the last oil paintings by Balthus, but it rehearses the
themes of his long career. The sexual theatricality of the gestures
and the stillness of the scene are in place. A few more bands
of colour will be added to the fabric on the bed.

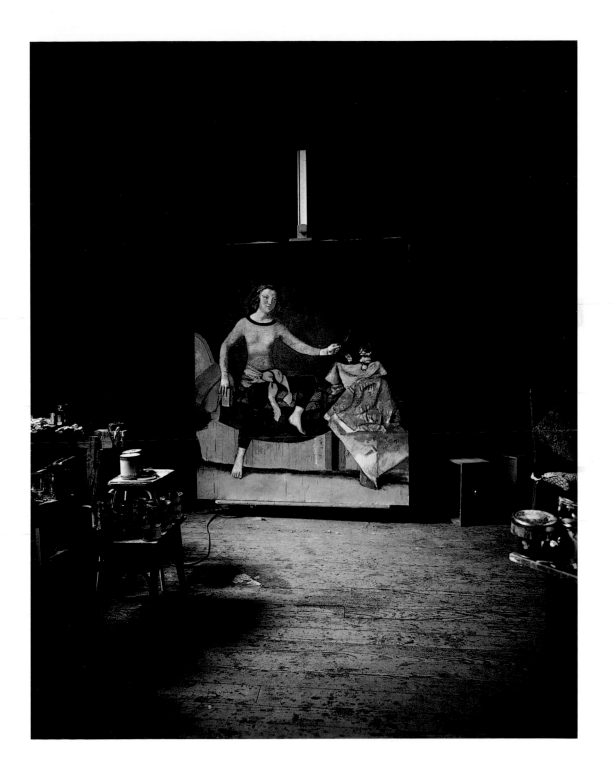

25
Robert Macpherson (1811–72)
View in the Italian campagna (1855–65)
Albumen-silver print from wet collodion on glass negative
Blind-stamped on mount: *R. Macpherson / Rome*
inscribed in pencil: *110*

Macpherson established himself in the 1850s as perhaps the
most admired supplier of large photographs of Rome and the
surrounding campagna. His church interiors sometimes entailed
exposures lasting days. Views such as this one exemplify his
adroit use of a very large camera, designed to accommodate
large glass negatives before enlargement became easily
practicable. Macpherson arranges in one generous oval the
masses of Roman ruins, a far away church, farm buildings,
cypresses, vines and the latest addition – telegraph wires.

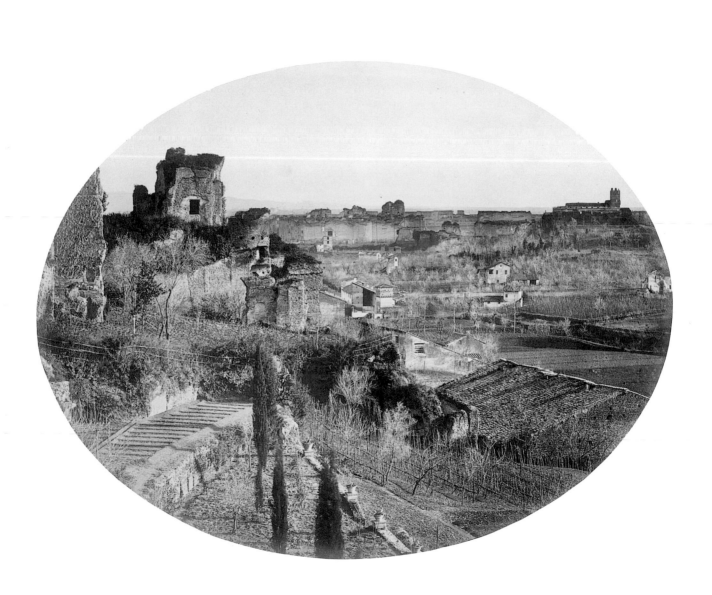

26
Frantisek Drtikol (1883–1961)
Winter Light (1931)
Pigment print
Blind stamped lower right: COPYRIGHT/DRTIKOL PRAGUE

Drtikol trained in Munich at the end of the Art Nouveau period,
the style of his early works. In the 1920s he created the
photographic equivalent of an Art Deco style, posing models
with a variety of curved and angular studio props, for which
he received a medal at the Paris 25 exhibition. His models were
generally Prague dancers, and here he seems to have created
a third style, dispensing with props. This intimate study, with
wintry light from Drtikol's photo-floods, suggests that he was
responding to the visual language of cinema close-up.

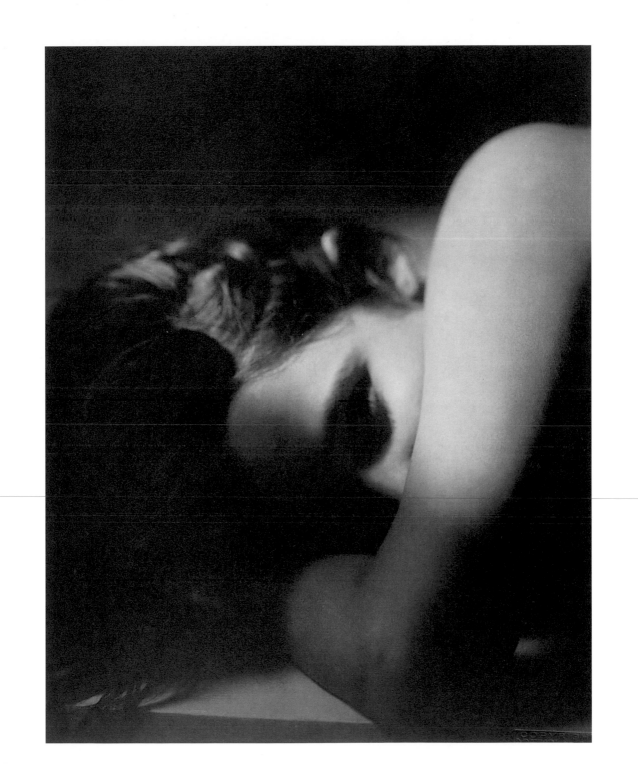

Anon
Veteran of Waterloo with his Wife (1850s)
Ambrotype (collodion positive), lightly tinted

Bruce Bernard first saw this unusual photograph when it was
sold at Christie's in London in the late 1970s. He reproduced it
in the *Sunday Times Magazine* and his book *Photodiscovery* in 1981.
He tracked it down a quarter of a century later to add to this
collection. The medal on the old man's lapel identifies him as a
Waterloo veteran. Ambrotypes are actually slightly underexposed
glass negatives, made to appear positive by the black background
on which they rest in their cases. Husband and wife have elected
quite different ways of posing for the photograph.

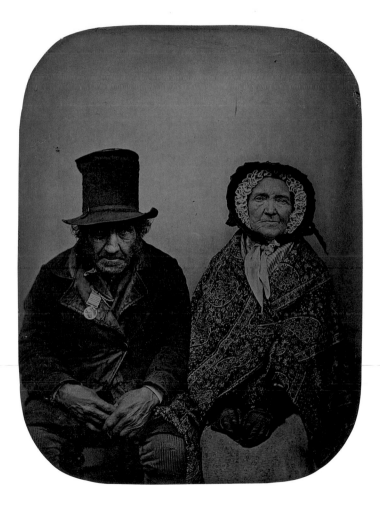

28
Ken Griffiths (b.1945)
Julie (1990)
Platinum print
Signed and dated on mount

Ken Griffiths made this affectionate portrait of Julie in Lincoln's
Inn Fields, a favourite haunt of hers in London. Griffiths used a
10 x 8 inch Gandolfi camera, which encouraged a certain pride
in the pose, but it was said that Julie had once been a model
and she was too proud to beg. Platinum paper was used for
stressing the warmth Griffiths felt for his subject and her
ingeniously assembled attire. Platinum paper, whose heyday was
around 1900, has a particularly long tonal range. It is often
revived these days, but rarely to such good purpose as here.

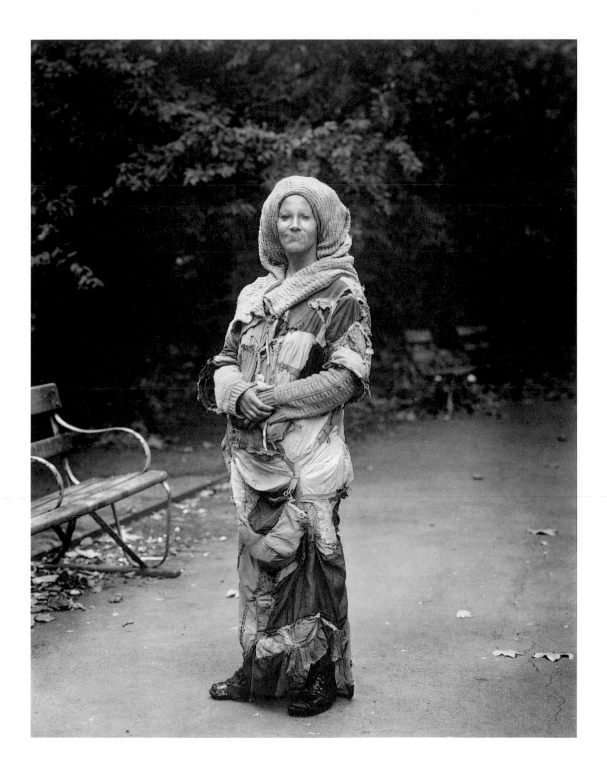

29
August Sander (1876–1964)
Mardi Gras Distortion (c. 1931)
Gelatin-silver print

Sander is best known for his vast taxonomical survey of German life, *Menschen des 20. Jahrhundert (People of the 20th Century)*. The generally frontal portraits of the series are perfect expressions of *die Neue Sachlichkeit* ('the new reasonableness'). However, Sander – who trained initially as a painter in Dresden – was not limited to one style. Here he suggests the spirit of a Mardi Gras celebration by distorting a print by tilting it beneath the enlarger to lengthen the faces and create a suitably fantastic perspective.

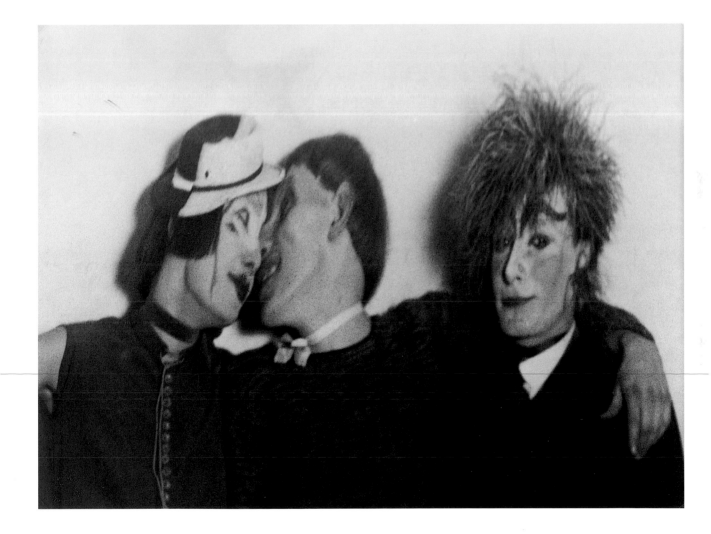

30
Werner Bischof (1916–54)
Silk drying, Kyoto, Japan (1951)
Gelatin-silver print
Stamped on reverse: ABC press, Amsterdam

The Swiss-born Bischof joined the international cooperative of photojournalists, Magnum, in 1949. Beginning with reportage projects in England, Scotland and Italy, he moved on to the places which most inspired him – South America, India and Japan. His career came to an untimely end in the Andes in 1954, but his lyrical gift provided key images for Edward Steichen's *The Family of Man* a year later and helped to shape photojournalism for a generation.

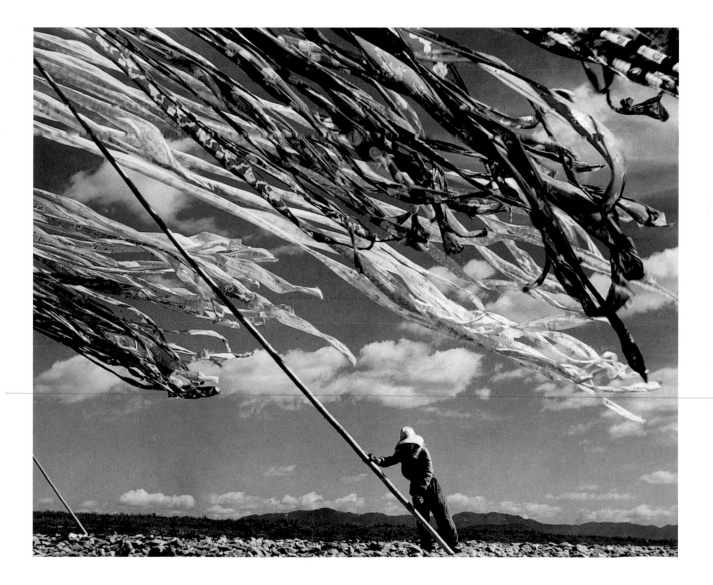

31
Heinrich Kuhn (1866–1944)
Die Brise (c.1910)
Gum-bichromate print

Kuhn was German-born but moved for health reasons to
Innsbruck, Austria. From here he conducted photographic forays
into Holland, northern Germany and Italy, and sent
photographs to exhibitions in Vienna, London, Paris and New
York. His style was initially based on the Munich Secession
painters. In 1904 he accepted suggestions from Alfred Stieglitz
that inclined him towards intimate figure studies like 'Die Brise'
(The Breeze). He became the leader of art photography in
continental Europe, using the gum-bichromate process to make
delicate tonal studies such as this.

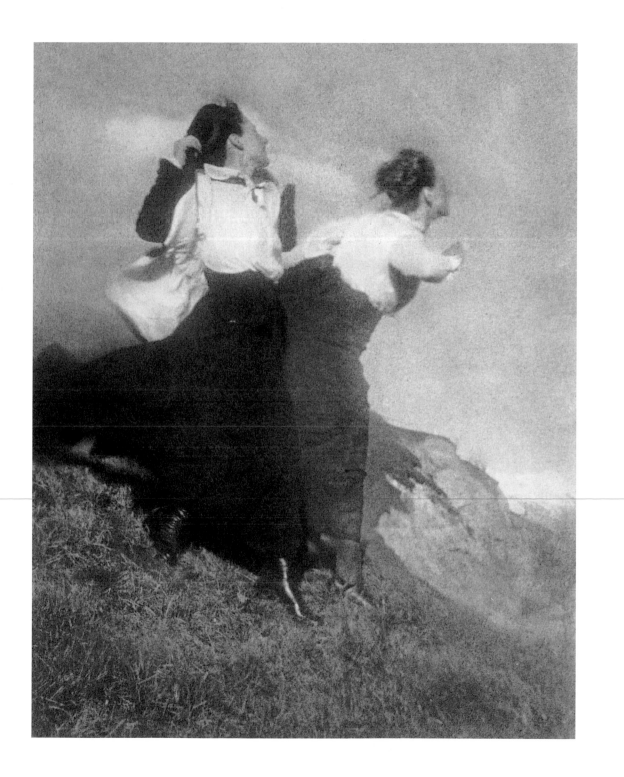

32
Weegee (Arthur Fellig) (1899–1968)
Gunfight (1944)
Gelatin-silver print
Inscribed in ink: *To Kay Cremin, Weegee, 1944*
Weegee's stamps on reverse plus inscription in pencil

Weegee was the archetypal hard-boiled New York press
photographer, armed with a Graflex and flash, a radio to pick
up police messages, a press card and, if that failed, plenty of
cunning. He wrote on the back of this print: *This was gunfight in
a bar, fighting over a woman. This Portuguese woman wouldn't let him
go, wouldn't even let the cop tear her away when they put him in the
ambulance. Sure, he died. The cops weren't letting any press on the
scene, so I crawled in a back window and took it from up top.*

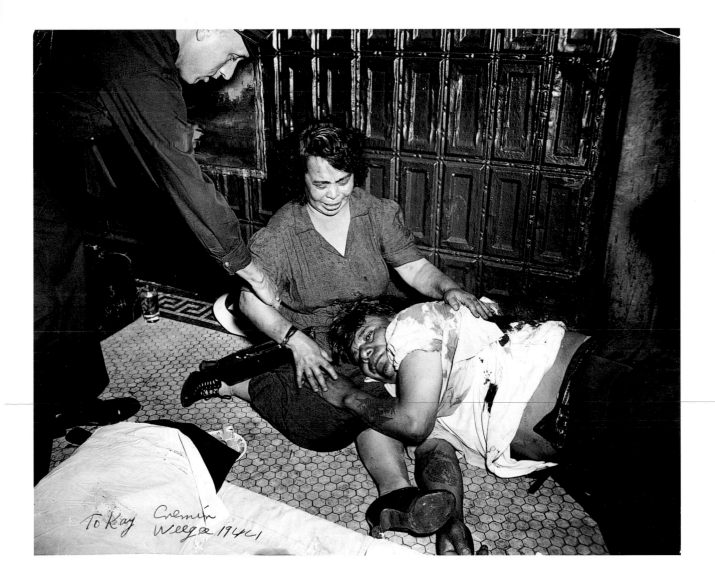

To Kay Cremin
Weega 1944

33
Peter Lavery (b.1948)
Caroline Gerbola on Conchita, Fossett Bros. Tralee, Ireland (1986)
Signed in pencil on mount

This is from a project by Peter Lavery published as *Circus Work, 1970–96* (1997), with an introduction by Bruce Bernard: 'Something must be said about the role of backgrounds in Lavery's portraits and his ingenuity and perception in their choice and variety. He seems intent on using them very judiciously, never overcrowding or stepping back that inch or foot too far which would cause the main subject to suffer. He can make his backgrounds a brilliant enhancement of the figure, as here, where Caroline Gerbola's horse is shot in an Irish country lane that renders the scene extraordinary but absolutely right'.

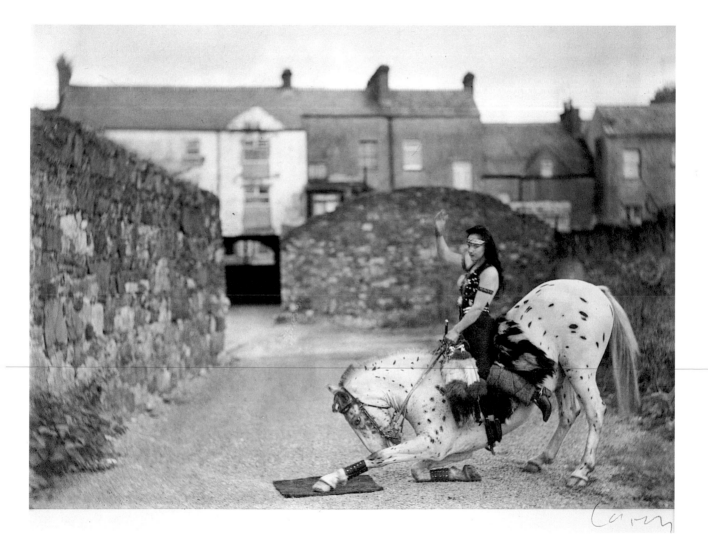

34
Charles Nègre (1820–80)
The Recreation Room, Vincennes Imperial Asylum (1858–9)
Salted paper print from wet collodion negative

An imperial decree of March 1855 confirmed Napoleon III's
wish that an asylum be constructed as a convalescent home for
sick or injured workmen. Charles Nègre was commissioned to
produce a commemorative album around 1858. His instruction
was to document the architecture and the internal activity of
the asylum. In order to achieve rapid exposures in the relatively
dark interiors, Nègre used small wet collodion on glass plates
and then made enlargements. Here, supervised by uniformed
attendants, the inmates relax in their smocks and straw hats,
some leaving shadowy afterimages.

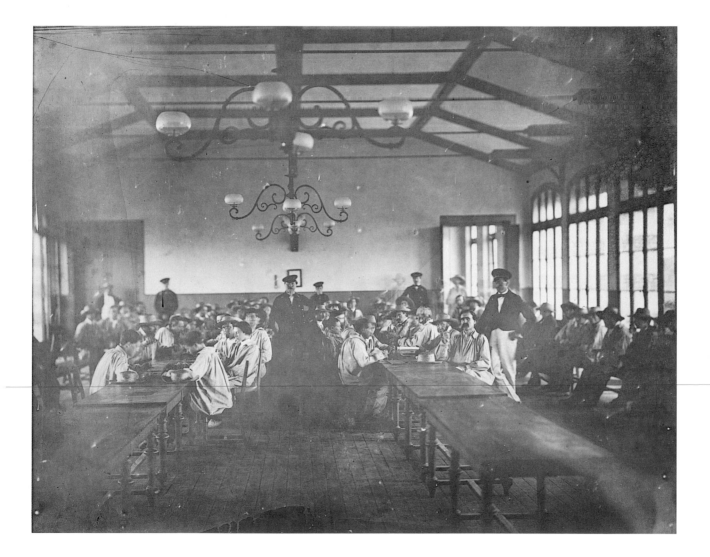

35
J. Walter Collinge (active 1920s)
They Watch (c.1924)
Gelatin-silver print
Signed and titled in pencil on the mount
Signed, titled and addressed in pencil on reverse

Collinge, of Santa Barbara, California, was probably an amateur photographer. His photograph probably appeared in the salons of photographic clubs. He showed no signs of interest in the high-definition photographs, printed on glossy commercial papers, for which Californian photography was soon to become well known through such masters as Edward Weston and Ansel Adams. Instead he chose relatively muted tones to evoke the US naval presence in the Pacific, adding only a stately and resonant title.

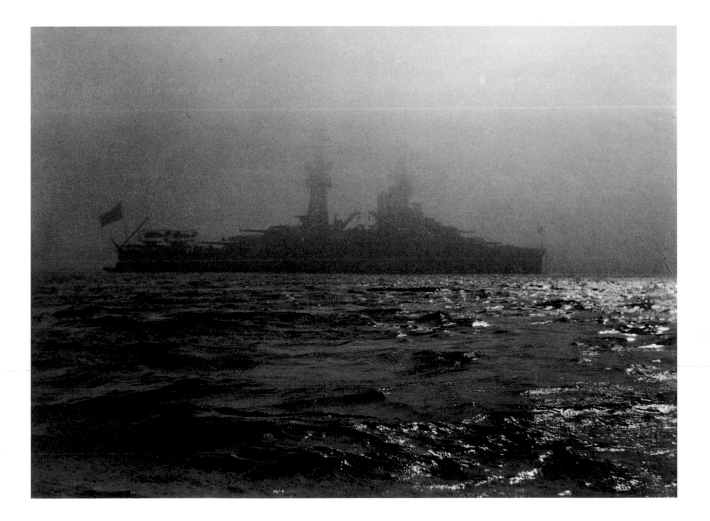

36
Gösta Peterson (b.1923)
Key West, Florida (1968)
Gelatin-silver print
Inscribed in pencil on reverse: *MLLE / DEC-'68 / PRINTED — 70*

This photograph was made for *Mademoiselle* magazine, New
York. The model was Carol Cawthra and the stylist Deborah
Turbeville, who had successful careers as a model and a
photographer. Gösta Peterson has specialized in photographing
the erotic aspects of women's athletics, here for White Stag-
Speedo swimwear. The female cyclist inspired a brief poem
by Sir John Betjeman which focuses enviously on the saddle.

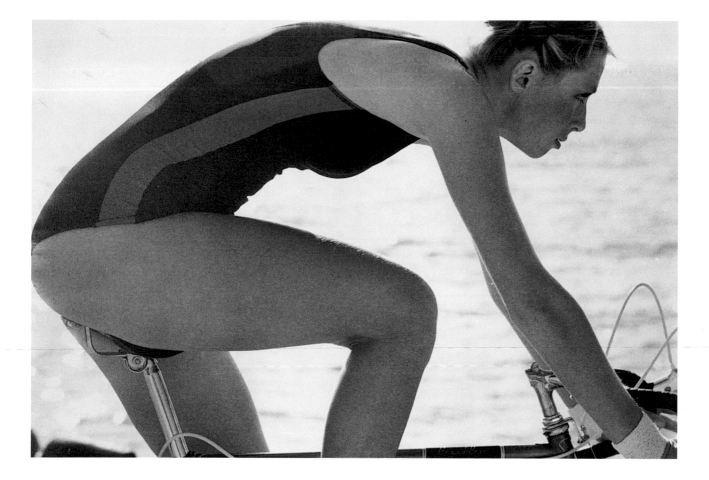

37
William Klein (b.1928)
Fighter-Painter Ends Mural, Tokyo (1961)
Gelatin-silver print
Titled, signed and dated in pencil on reverse

Shinohara, alias 'The Mohican', alias 'The Fighter [or Boxer]
Painter', was the subject of several striking photographs by
William Klein, whose book *Tokyo* (1961) brought the vigour
of New York to photography in Japan. The graphic energy and
sophistication of Klein's photographs found ready admirers in
the Tokyo avant-garde. This photograph is the climax of the
series, in which the painter's primal gestures contrast pointedly
with the Western architectural forms filling the background.

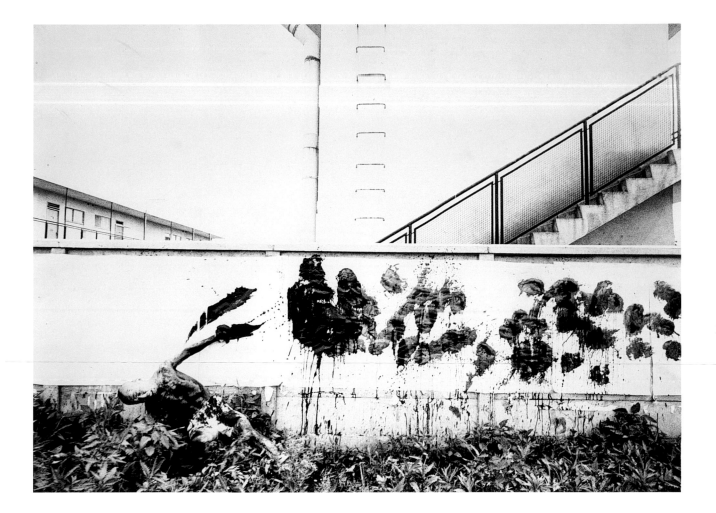

38
Harry C. Ellis (1857–c.1928)
Auguste Rodin, Rose Beuret and Loie Fuller in Rodin's atelier, Meudon, France (c.1916)
Gelatin-silver print signed in ink by Rodin

To the sculptor's right is his loyal companion, housekeeper and common-law wife Rose Beuret, the mother of his son Auguste. To her right is the last person you would expect – Loie Fuller, the American dance sensation of fin de siècle Paris. The camera presents us with the brilliant artist and his handsome companion, contrasted with Fuller, who had – by 1916 – lost her looks and gained a new career as an important conduit of works from Rodin's studio to collectors in America. Rodin faces the camera genially, Meuret warily, while Fuller seems cheerfully oblivious.

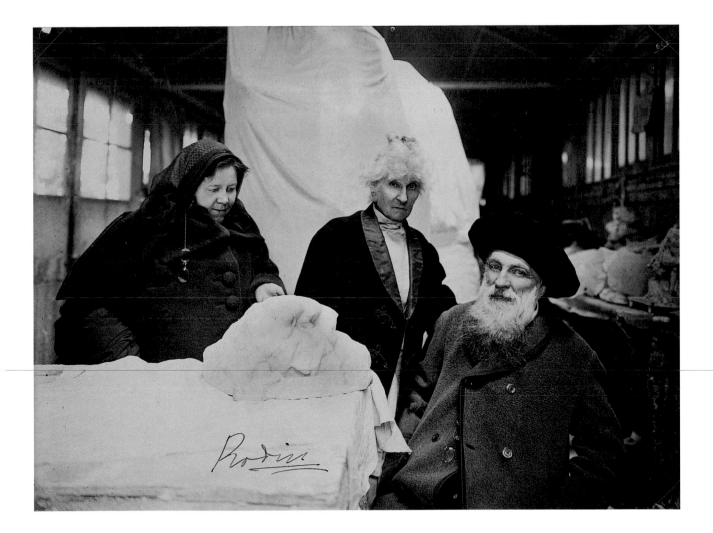

39
Baron Adolphe de Meyer (1868–1949)
Fashion, modelled by Chantieler (1918)
Gelatin-silver print

De Meyer was initially an amateur who exhibited with the major
art photography groups in London and New York, dissolving the
post-Whistlerian gloom that hung over early twentieth-century
photography by the striking use of back lighting. He graduated
from the austerely aesthetic pages of Alfred Stieglitz's *Camera
Work* to become, in 1914, the first contracted photographer
at *Vogue*. This work shows why Cecil Beaton praised him for
creating a new, silver world: 'His whites and silvers were
dazzling, and the subtlety of grey tones masterly.'

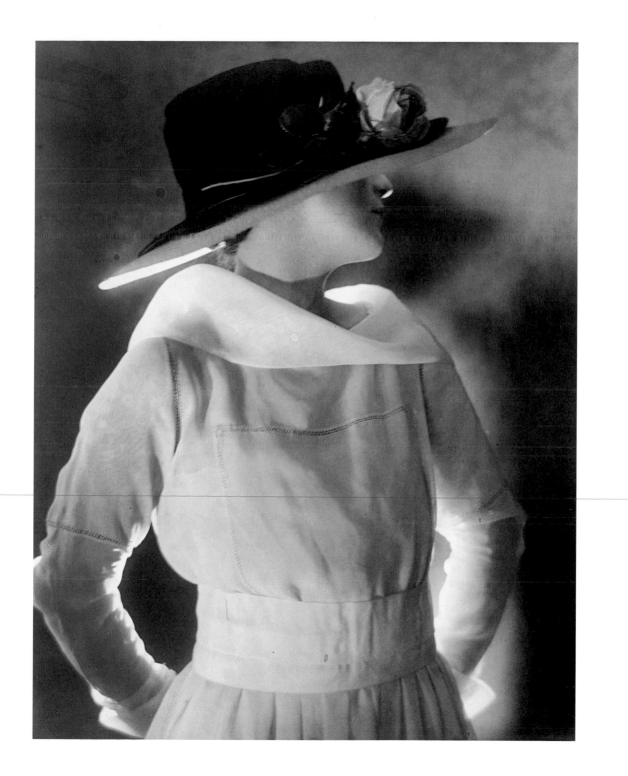

40
Louis-Alphonse de Brébisson (1798–1872)
*A Falaise, derrière le chevet de Saint Gervais - Vue prise de la fenêtre
de l'atelier* (1850s)
Salted paper print from glass negative

De Brébisson was in the first wave of French amateur
photographers using paper negatives in the 1840s, transferring
to glass in 1850. The enhanced speed of glass negatives made
this kind of photograph practical – capturing (on a relatively
small and therefore fast negative) the crowd which formed
conveniently outside de Brébisson's studio window. The nature
of the gathering is obscure – the men speaking from the cart
might be salesmen, preachers or politicians – but perhaps the
real subject is the ensemble of church, shops, carts and crowd.

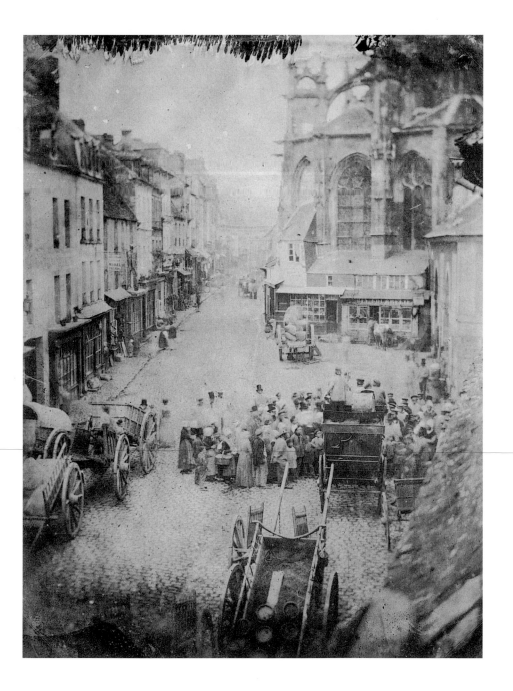

41
Man Ray (1890–1976)
Masque Punu du Gabon (1925)
Gelatin-silver print
Inscribed in pencil on reverse of mount: *Coll. Guillaume*

Man Ray occupied a central artistic position in Paris between the
two World Wars, simultaneously at the heart of the Surrealist
avant-garde, as a maker of paintings, improbable objects and
films, and a star fashion photographer at *Vogue*. As a portrait
photographer, he liked to monumentalize his celebrated sitters,
using solarization to give them the sheen and solidity of chrome.
Here, Man Ray photographs an example of the newly-collectable
art of African sculpture – paradoxically representing the wooden
mask as if it is relaxing in reverie.

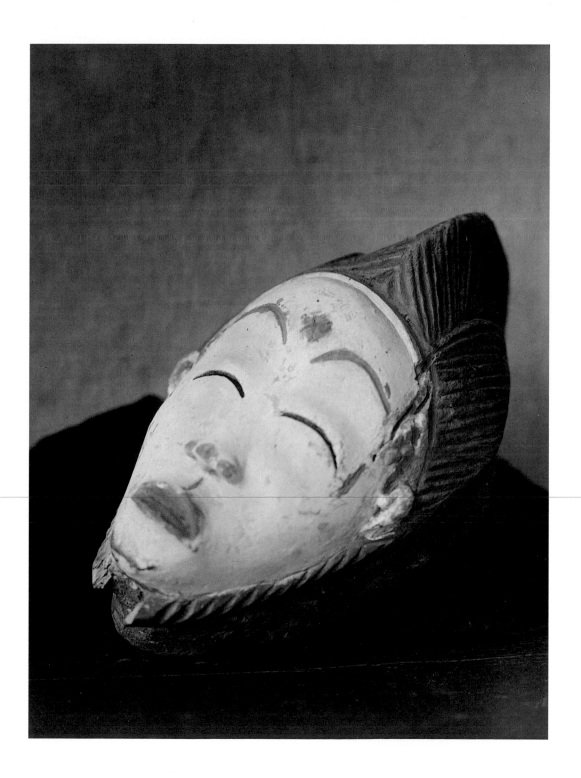

42
Louis-Alphonse de Brébisson (1798–1872)
Still Life (1850)
Salted paper print from glass negative

De Brébisson lived at Falaise, near Caen in Calvados. His still life assembles – in a pleasantly casual manner – a variety of household implements, cooking pots and produce. Although it might at first sight seem like the corner of a cottage interior, the shelf must have been outside as good daylight was required for the exposure. As 1850 is the year in which de Brébisson began using glass plates, this may have been an experimental piece, testing how the plate would record the intricacies of basketwork, the sheen on a *marmite* earthenware cooking pot and the textures of vegetables.

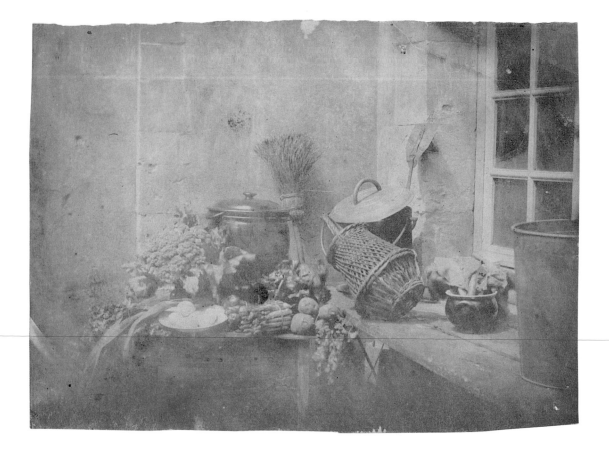

43
Markéta Luskačová (b.1944)
The Vigil for starke Gordanova, Sumiac, Slovakia (1971)
Gelatin-silver print

Markéta Luskačová began photographing pilgrimages in Slovakia
in 1967 and soon she began to photograph the village, Sumiac,
where one of her pilgrim friends lived. The piety of Christian-
peasant culture became Luskacova's first great subject, which
she photographed until 1974. She found that death, unlike in
modern societies, was accepted as the natural conclusion of
living. The curate would compose a chant for the dead person
in which the departed says goodbye to each relation and
neighbour, each by name and in strictly observed order.

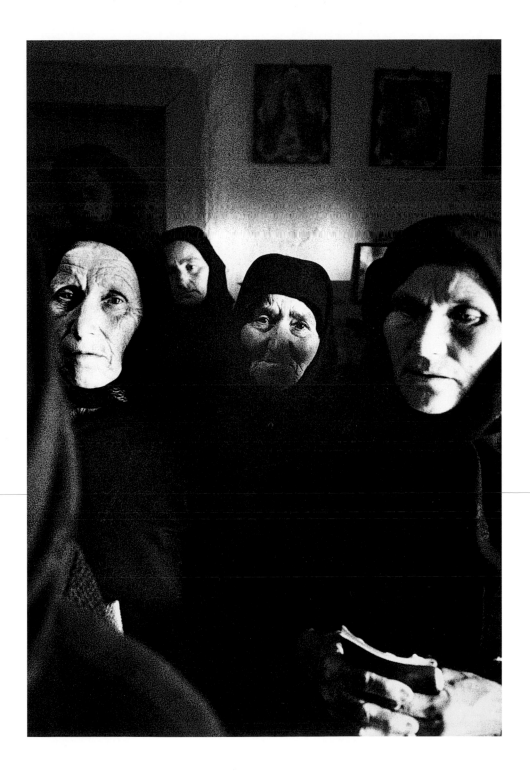

44
E. O. Hoppé (1878–1972)
Nude (c.1910)
Toned gelatin-silver print
Signed and inscribed in ink on print: (Proof.)
Stamped: *Proofed E. O. Hoppé*

The Munich-born Hoppé is in a long line of émigré talents –
including Claudet, Silvy and Brandt – who revolutionized and
refreshed British photography in the nineteenth and twentieth
centuries. Hoppé's studio in Millais House, South Kensington
provided the best portraiture in Edwardian London, but he
also designed for the theatre. He later became a major travel
photographer. As a photographer of the nude, Hoppé brought
a soft-focus Georgian modesty to the genre, combining a
sixteenth-century Brussels tapestry with the heroine of
a silent movie.

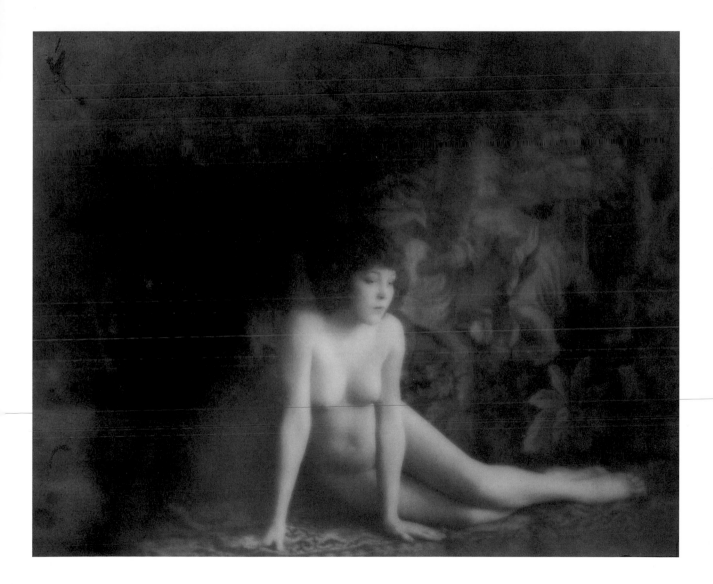

45
Toby Glanville (b. 1961)
Plasterer's Mate (1992)
C-type colour print

Glanville – who has made many portraits of workers in different
crafts, trades and skills – was visiting a friend's basement flat in
Notting Hill, which the boy was helping his father to plaster.
The only light came from a small southwest-facing window. The
boy is coated in fine plaster dust and his eyes are dilated as he
looks out from relative darkness. Glanville, using a Rolleiflex on
a tripod, counted out the exposure using the second hand of his
watch. Bruce Bernard said that he felt he could almost see the
boy's nervous system in this photograph.

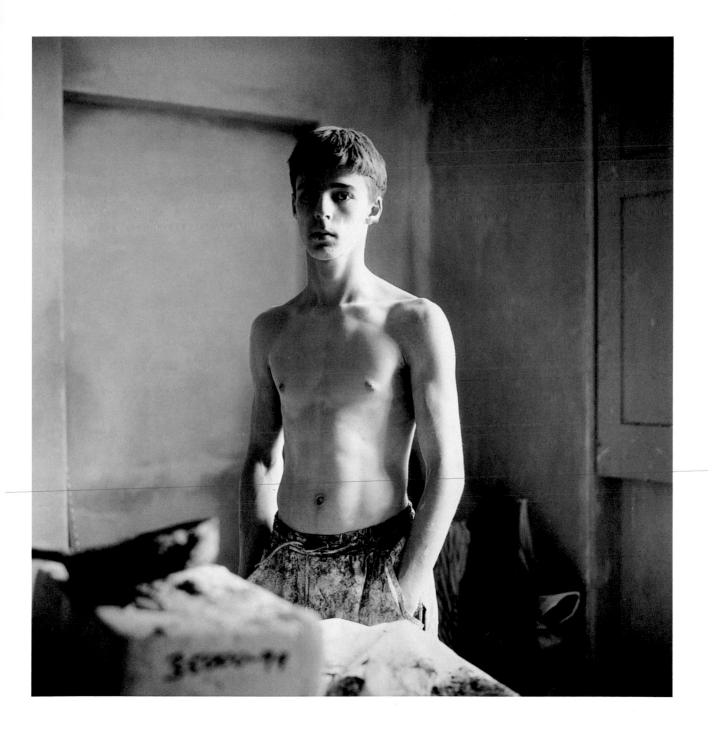

46
Harry Callahan (1912–99)
Cape Cod (1972)
Gelatin-silver print
Signed in pencil on print

Callahan turned seriously to photography after hearing Ansel
Adams speak at a camera club in Detroit in 1941. Among the
images Adams showed were his famous surf sequence. Callahan,
who taught for many years at Moholy-Nagy's Institute of Design
in Chicago, worked all of his life in sequences. He also often
photographed at the water's edge, from Lake Huron in the
1940s to Cape Cod in the 1970s. He thought that 'the best of
these beach pictures represents a finding of my kind of vision.'

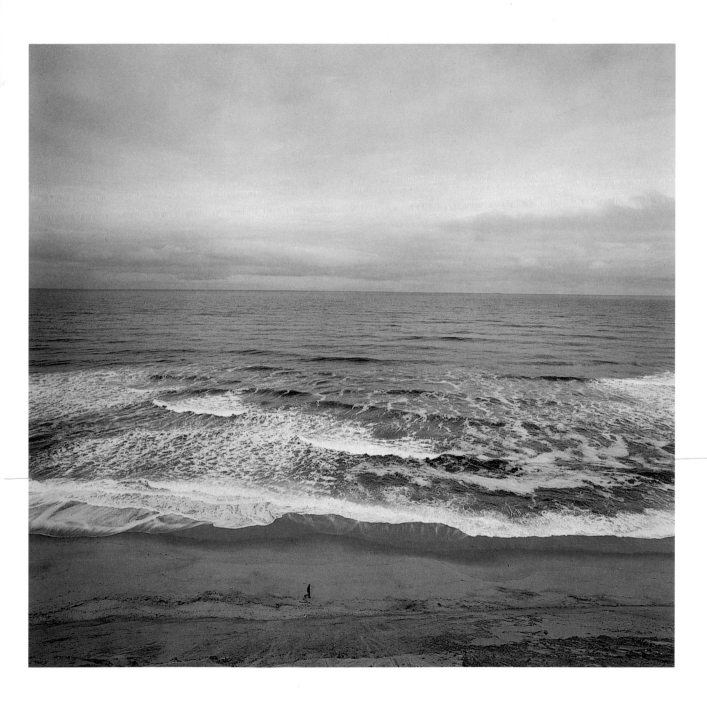

47
Kusakabe Kimbei (1841–1934)
Buddhist Procession (1881)
Hand-coloured photograph

The scene is the temple of Honmonji at Ikegami in southwest
Tokyo, and the photograph can be dated more or less precisely
to October 1881, when the 600th anniversary of the death of
the temple's founder, Nichiren, was formally marked by the
procession seen here, with the head priest of the temple
surrounded by priests and members of the local congregation.
Kusakabe, although himself a Christian, captured not only the
sheer physical volume of support for the Nichiren sect, but
also the mood of common purpose shared by its devotees.

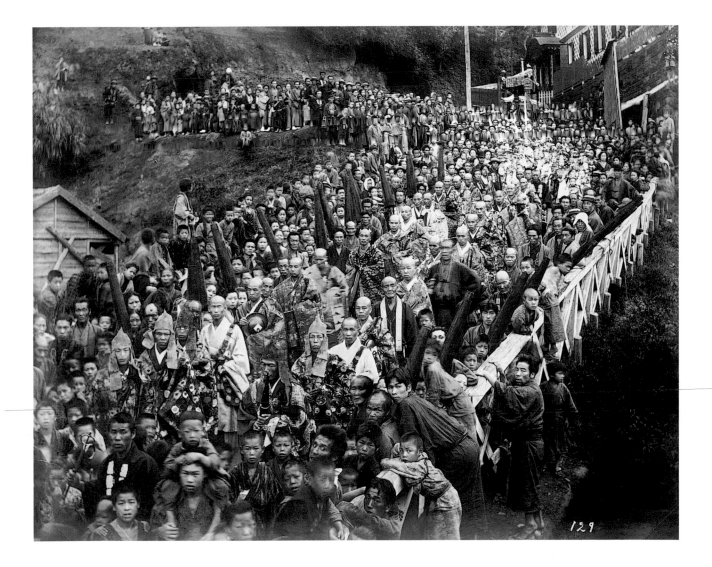

48
Louis Faurer (1916–2001)
Paris (1972)
Gelatin-silver print

Louis Faurer began as a street photographer in the 1930s and
became one of the stars of the magazines in the 1940s, bringing
blur, grain and double exposures to fashion. His apparently loose
and edgy street photographs are close kin to those of his friend
and colleague Robert Frank. Faurer visited Paris several times in
the early 1970s, which inspired a return to his best street work.
Here a vulnerable figure stands among the flying signage of the
city, in which we can make out the words 'CINEMA
CONCORDE' among the empty space and visual din.

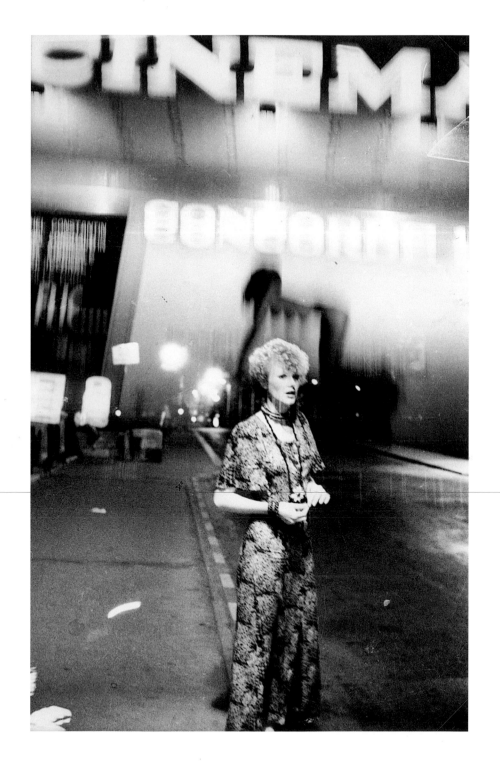

49
Anon
Untitled [Child, Teddy and Car], New Jersey (c.1935)
Gelatin-silver print

In recent years amateur snapshots have been increasingly
studied – welcomed under the rubric of 'vernacular
photography' – exhibited in galleries, traded and collected.
Some of the attraction lies in recognizing in the images of
apparently artless amateurs key stylistic characteristics of
photographers who were far from untutored. In this case, the
tilted lens, which may convey the plunging perspectives of a
child's fraught consciousness, also recalls a mannerism of
Aleksandr Rodchenko and the New York street photographer,
Garry Winogrand (1928–84).

50
Anon
Woman milking her breast (c.1960s)
Gelatin-silver print

Not all small, untitled anonymous photographs are by amateurs, nor are they always lost in time. This example looks expertly composed and lit. The square format and size suggest a contact print made from a negative from a medium-format camera like a Rolleiflex or Hasselblad. The subject, too, suggests an occasion in which both the photographer and the subject of the photograph are deliberately involved in fabricating an image – perhaps, as the lighting and the taboo-breaking nature of the event suggest, in the 1960s – but to what end remains a mystery.

51
Anon
Women in a tree (c.1920)
Gelatin-silver print

The principal attraction of the snapshot is that it dispenses with
the ambitions of high art in favour of the more readily realizable
goal of conveying high spirits. We seem to be out West,
perhaps with a view of the High Sierra, and these seem to
be American matrons who have established themselves so
exuberantly in the eyrie of an unfeasibly small but sturdy tree.

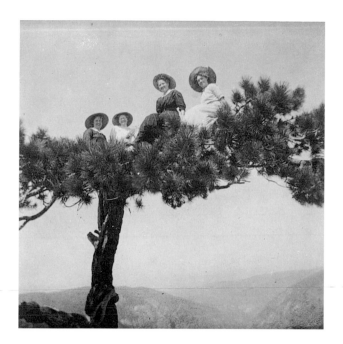

52
Anon
Three studies of the construction of the Holland Tunnel, New York City
(1922/23)
Gelatin-silver prints

These gritty documentary photographs capture the realities
of constructing one of Manhattan's major links to the mainland.
The typed details on the back include:

1 *Rear of shield North Tunnel - New York: Turnbuckles, etc. Injury*
to Inspector Blakeslee 1-31-23 4.00 P.M.

2 *Canal Street Shield - New York 9.29.22 10.00 a.m. View looking*
down Canal Street Shaft, New York City, showing progress in erection
of shield. Camera set in prone position on an overhanging platform ...

3 *Working chamber of North Land Shaft Caisson, New Jersey 1.31.23*
10.30 A.M: View of silt in working chamber when it is about 75%
mucked out ready for a drop.

53
Don McCullin (b.1935)
A man and his three wives returning from a funeral.
Irian Jaya, New Guinea (1992)
Gelatin-silver print

McCullin became one of the world's most compelling
photojournalists because of the unsparing realism and dramatic
intensity of his coverage of wars and famines in Vietnam, Biafra,
the Congo, Bangladesh and the Lebanon. His photo-essays were
published in the *Sunday Times Magazine*, which he left when he
felt that it had been taken over by lifestyle features. He has
done much work since, often self-assigned. The woman is
covered in ashes as a sign of respect. McCullin faces the group,
Bruce Bernard wrote, 'with his customary tough sympathy'.

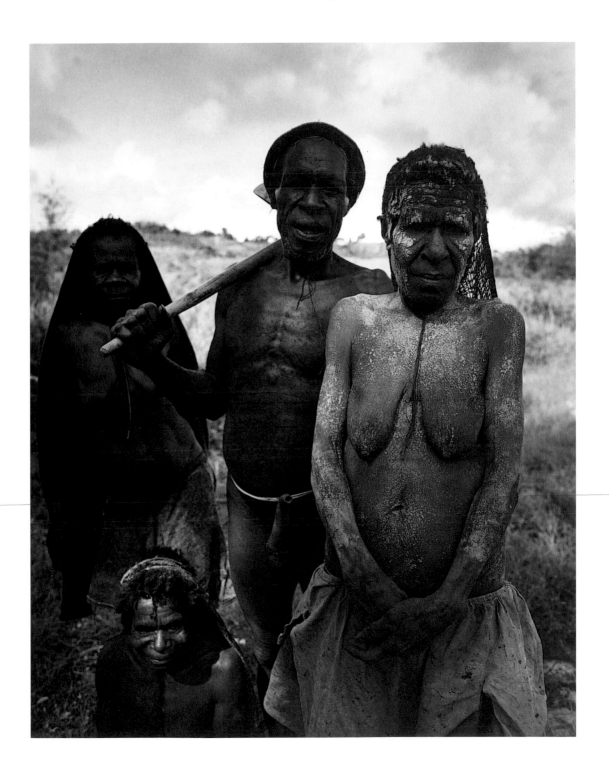

54
Clemence Jacob Delmaet (d. c.1890) and Louis-Emile
Durandelle (1839–1917)
Le Nouvel Opéra de Paris: Sculpture Ornementale (c.1866–9)
Albumen-silver print from glass negative

This is one of the on-site workshops of sculptors working high
up on the new Paris opera house. Charles Garnier's exuberant
Beaux Arts building was intended to be the crowning glory of
the Second Empire, but construction was interrupted by the
Franco-Prussian War and it eventually opened under the Third
Republic in 1874. Garnier commissioned a rich documentary
series on the building from Delmaet et Durandelle. Like other
studio photographs, their image contrasts the perfected work
of art with the muddle and chaos from which it was created.

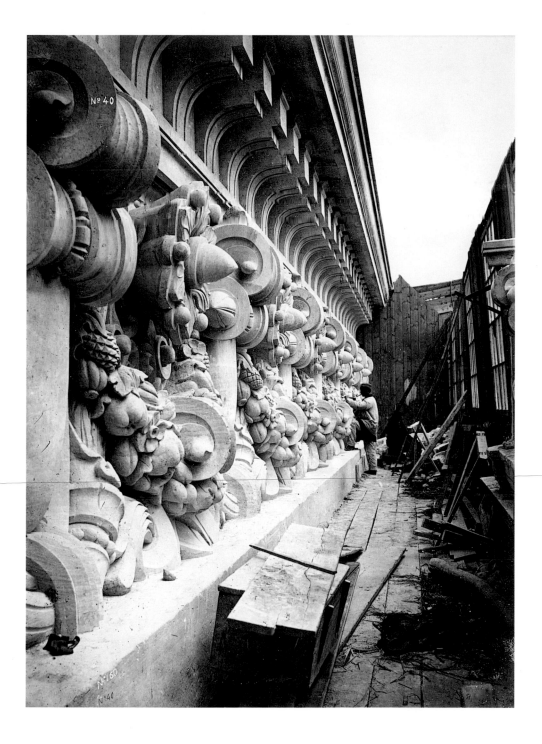

55
E. O. Hoppé (1878–1972)
Le Spectre de la Rose, Nijinsky, Ballets Russes (c.1911)
Photogravure

Hoppé became the unofficial photographer of Diaghilev's Ballets
Russes in London. Fifteen photogravures, including this one,
were published as *Studies from the Russian Ballet* by The Fine
Art Society in 1913. *Le Spectre de la Rose*, based on a poem by
Théophile Gautier, with music by Weber, sets by Bakst and
choreography by Fokine, was first performed in 1911 and
became the most popular work in the repertoire of the Ballets
Russes. 'No one who saw Nijinsky dance the role of the
Rose ever forgot it,' wrote Richard Buckle in his biography
of Diaghilev.

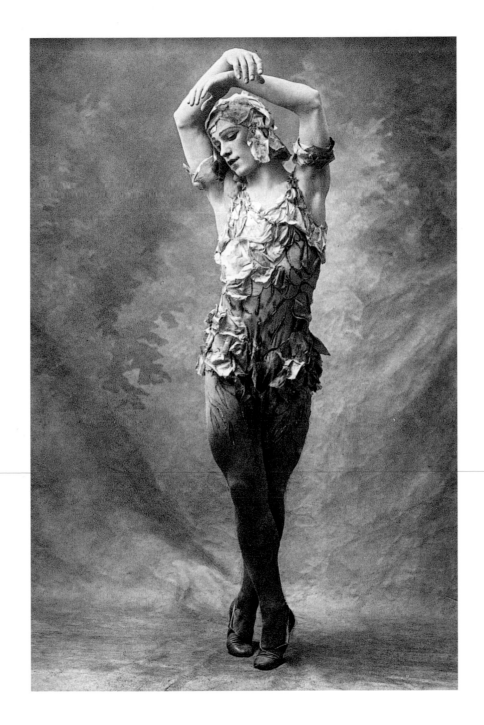

56
Pach Bros of New York (active 1860s–1900s)
Thomas A. Edison (1906 or 1908)
Toned gelatin-silver print
Inscribed: *COPYRIGHT 1908* [or *06*] *BY PACH BROS. N.Y.*

Edison (1847–1931) is shown at his desk speaking into a
microphone. The combination of his Yankee know-how,
extraordinary inventiveness and rags-to-riches career made him
a folk hero. By his mid-thirties Edison was the best-known
American in the world. Photographers spread his image and his
fame. The Pach Brothers used flashlight powder (invented in
Germany in 1887), which bathes the inventor in the light of
celebrity. Light bounces off every bright surface and irradiates
the man who, more than anyone, created the electric world.

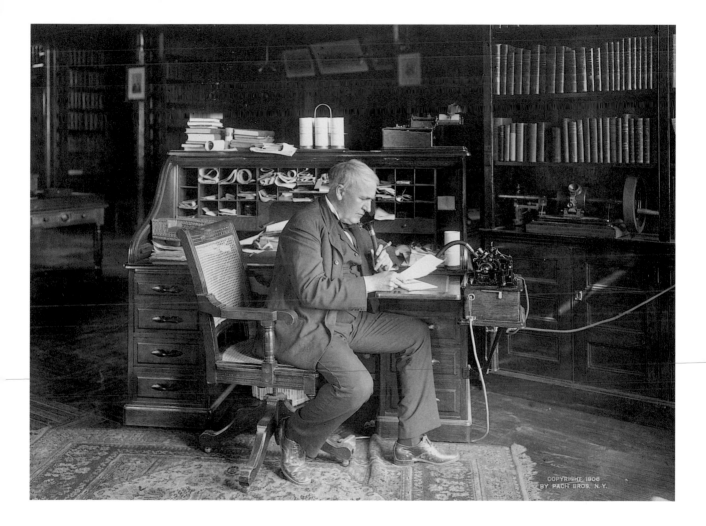

57
Jack Delano (b. 1914)
Florida Migrants at the Little Creek – Cape Charles Ferry (1940)
Titled and dated on typed slip on mount

Delano began working for the Farm Security Administration, an
enlightened agency of the New Deal, in 1940. He and his fellow
photographers, such as Walker Evans and Dorothea Lange, were
officially described as 'Artist-Photographers'. Their role was to
photograph the agricultural communities whose needs were
addressed by the agency. On his first trip to the South, Delano
discovered that you 'don't shake hands when introduced to
a black man, don't address a black man as "mister"', etc.
His photographs of migratory farm labourers, mostly black,
eloquently presented his own and the New Dealers' view
of their plight.

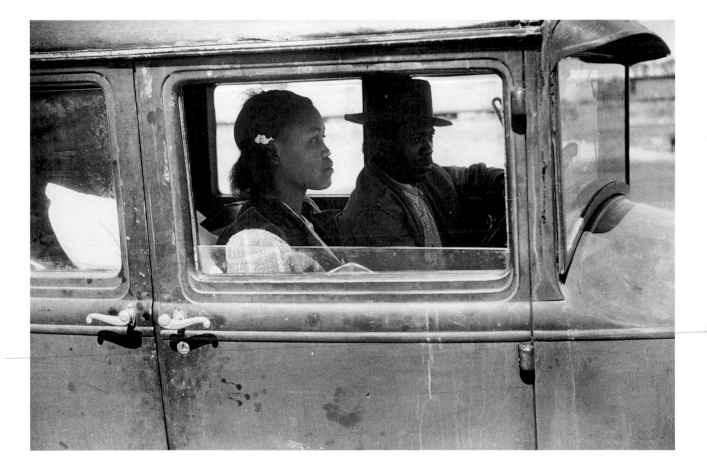

58
Robert Wiene (1888–1938)
Still from *The Cabinet of Dr Caligari* (1919)
Gelatin-silver print
Stamped on reverse: *return to h.weinberg*
228 west 71st, New York City

The sets of *The Cabinet of Dr Caligari* were dominated by painted
backcloths featuring curves and cubes, distorted perspectives and
elongated furniture. The story revived many themes of German
Romanticism – death, tyranny, fate and disorder, haunted
students, mad doctors, dummies and somnambulists. Here
Dr Caligari, played by Rudolph Klein-Rogge, lies in bed willing
the hapless somnambulist Cesare to kill the innocent student
Alan. If the figure on the bed looks familiar, it is because the
film has influenced countless later horror films.

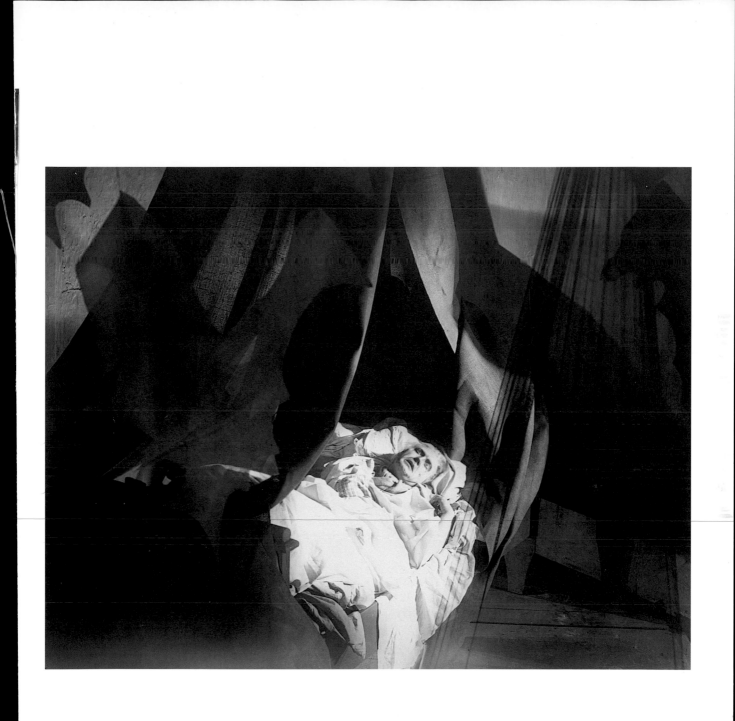

59
W. Eugene Smith (1918–78)
Tomoko with her mother beside the Bath (1972)
Gelatin-silver print
Inscribed in pencil on reverse: *Tomoko w/ mother / bath*

This photograph shows Tomoko Uemura, a young girl who
suffered from mercury poisoning (caused by methyl-mercury
effluent discharged into Minamata Bay, which affected fish and
shellfish), being bathed by her mother. It is not the photograph,
which became an icon of modern reportage and an indictment of
industrial pollution, but it was from the same session.

In January 1998, W. Eugene Smith's widow, Aileen Mioko Smith, felt that the widespread publication of this and other images of Tomoko and her mother caused undue pain to the family and decided to limit its usage so that Tomoko's spirit could rest in peace. We are therefore unable to illustrate it here. Following are excerpts of a statement by Aileen Smith:

'The decision to no longer release anew photographs of Tomoko and her mother in the bath was made after a great deal of deliberation, with love and care.

I would like to tell you a little about Tomoko's family. Photography is neither medicine nor god and the photograph "Tomoko and her Mother in the Bath", in spite of its release worldwide, could not cure Tomoko's illness, which was the result of being contaminated with deadly organic mercury from a Japanese sea polluted with industrial waste. Her mother had unknowingly eaten contaminated fish while pregnant with Tomoko, and the poison had gone through the placenta to the child. Tomoko's parents called their eldest, Tomoko, a "treasure child" because she had absorbed the poison that would have remained in her mother otherwise. Because of Tomoko having taken away the poison from her mother, all of Tomoko's siblings, five girls and a boy, were not afflicted with Minamata Disease like Tomoko.

Prejudice remained, and still does to this day, against those who have members of the family afflicted by Minamata Disease. This makes marriage difficult if not impossible in some cases.

In 1976, shortly after her rights of passage into adulthood and shortly before her siblings reached marriageable age, Tomoko died.

After Tomoko's death, this photograph meant something different. It wasn't about Tomoko anymore, a life being lived, but about continuing to reach out to the entire world, seeking the extermination of pollution, expressing the love of Mother and child.

Over the years it became a greater and greater burden for me to continue to answer to the publication of this photograph. Tomoko's parents remained silent, but I knew how they felt because I know how I feel. I kept telling myself, "I know people have been moved, even their lives changed by this image. I must continue to release it to the world. It is my duty." But gradually, this was turning to profanity. I knew that Tomoko's parents, now nearly a quarter century since her death, wanted Tomoko to rest. "Yasumasete agetai" were their words. And I felt the same. I literally felt Tomoko's efforts over these two and a half decades each time going out to the world, naked, showing everything of her polluted body.

This photograph would mean nothing if it did not honor Tomoko. This photograph would be a profanity if it continued to be issued against the will of Tomoko and of her family. Because this was a statement about Tomoko's life, it must honor that life and by it that death.'

60
Roger Fenton (1819–69)
William Simpson, War Artist (1855)
Salted paper print from wet collodion on glass negative
Engraved on mount: *published by printsellers in Manchester, London,
Paris and New York on 5 April 1856*
Inscribed in pencil on the mount: *'Crimean' Simpson*

Fenton made the first extensive photographic documentary of
war, which was published afterwards in three folios. Simpson
did the same in watercolour, lithographic versions of which were
published in 1855–56. Fenton captures his colleague in a languid
pose, while the sky beyond is dramatically veiled by chemicals
(due to problems developing the glass negative). As sometimes
happens in other Fenton photographs from the Crimea,
processing problems suggest the crisis of battle more successfully
than was possible with the slow lenses and films of the 1850s.

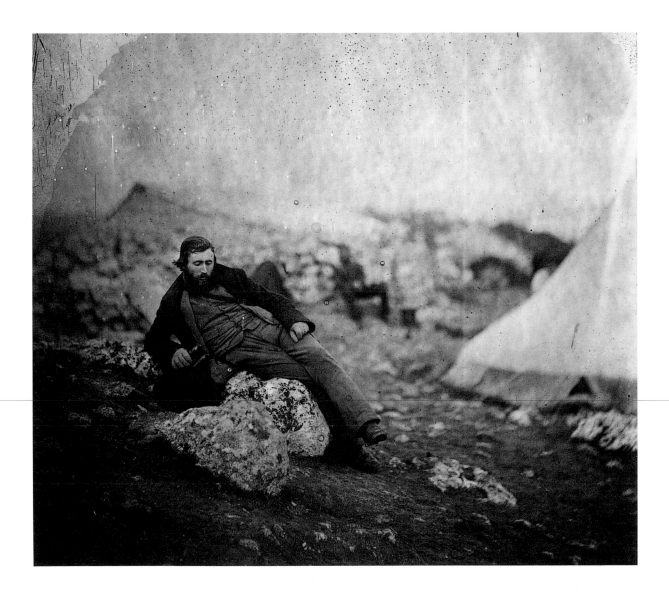

61

Horatio Ross (1801–86)

View in Edinburgh (1856)

Salted paper print from wet collodion on glass negative

Inscribed on mount: *April 1856*

Ross was one of the earliest amateur photographers in the
world, making extraordinary outdoor daguerreotypes of fly-
fishing and deerstalking in the 1840s before turning to the new
technology of the glass negative in the 1850s. This is one of his
homages to the rich spectacle offered by his country's capital,
with its combination of Gothic and classical buildings, looming
castle, handsome squares and vistas from the West End of
Prince's Street at 2.25 one afternoon. The warm-toned salt print
perfectly evokes the hue and texture of sunshine on masonry.

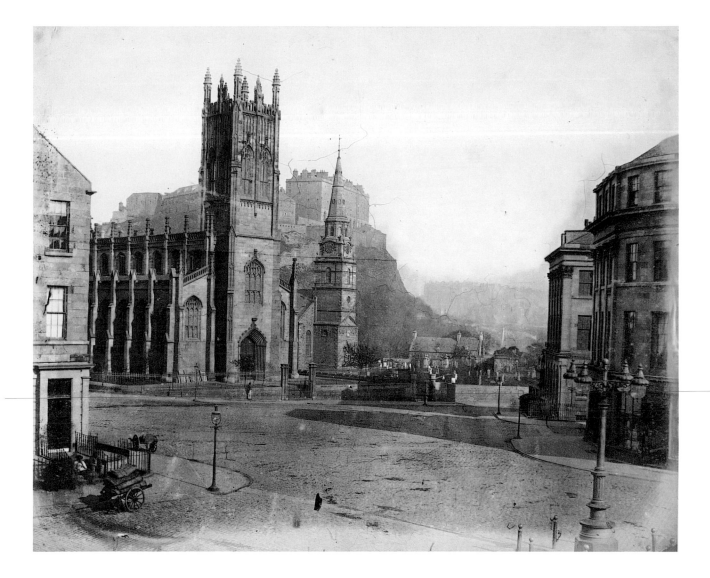

62
Roger Mayne (b.1929)
Footballer and Shadow, Southam Street (1956)
Gelatin-silver print
Signed and dated on the border of the print plus date of this
print (1987)

This is from Mayne's celebrated series, photographed between
1956 and 1961 in one street in Notting Dale in London W10 –
the district also celebrated by Colin McInnes in his novel
Absolute Beginners (1959). Mayne was one of the first British
photographers to buy Cartier-Bresson's classic book *Images à
la Sauvette* (1952). This 'decisive moment' shows the goalie's
flying leap, his bizarre and unlikely shadow, the striker's tense
stare – and (the beauty of such photographs) the ball
permanently suspended above or below the bar.

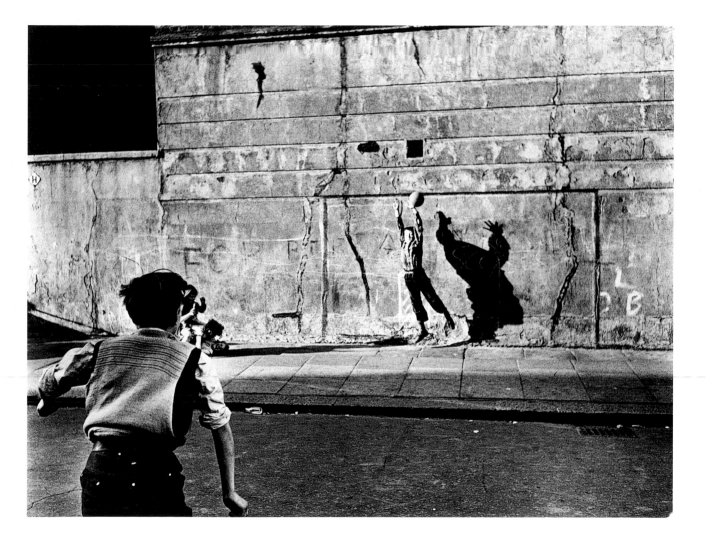

63
Eadweard Muybridge (1830–1904)
Man Pole-Vaulting (1887)
Plate 165 from *Animal Locomotion* (1887)
Collotype

Bruce Bernard's friend Francis Bacon was closely studying
Muybridge's *Animal Locomotion* series – the immediate precursor
of cinema – at the time they first met in the late 1940s, making
use of the images of a handicapped child and a dog in some of
his most disturbing canvases. This image, on the other hand,
presents Muybridge's instantaneous sequences – the precursors
of cinema – in a lyrical light. The twenty-four exposures, from
two sides, trace the action of a pole-vaulter from powerful
spring and soaring arc to final graceful landing.

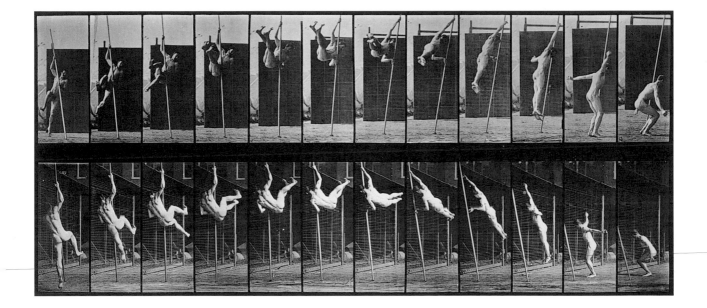

64
John Riddy (b.1959)
Belem (1997)
Gelatin-silver print
Signed, titled and dated with edition number (3/5) on label on
reverse of mount

Bruce Bernard thought this the best night photograph he had
seen. It has all the virtues of Riddy's photography: a long look
at an intriguing structure – a 1960s restaurant on the outskirts
of Lisbon – and a print which uses all the subtleties of the
grey scale. The glittering promise of the floodlit building is
accompanied by visual subplots which repay sustained looking:
the strange patterns in the water (caused by the long exposure),
the play of optical phenomena between constructed reality and
reflected illusion, and the sparkle of innumerable light sources.

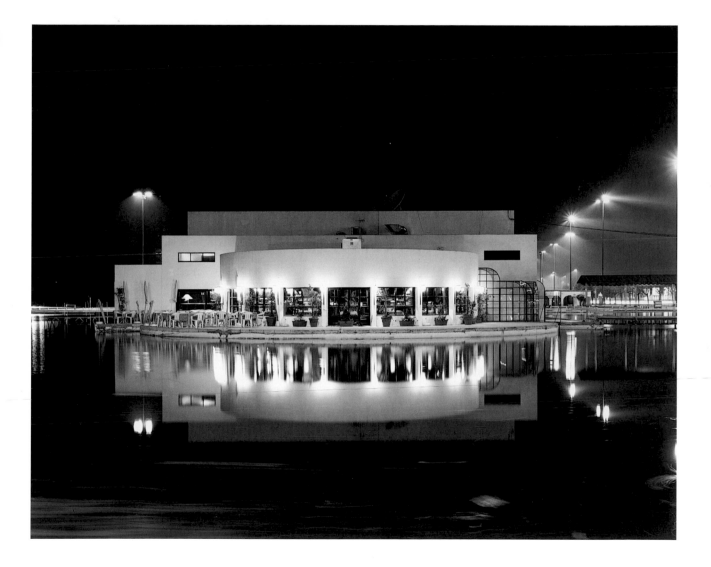

65
T. Lux Feininger (b.1910)
Vue de ma fenêtre 129 Perry Street N.Y.C. Spring (1941)
Gelatin-silver print
Signed, titled and dated in pencil on the reverse

Feininger, born in Berlin in 1910, studied both painting and photography at the Bauhaus and became one of the most inventive photographers of the time, a member of the agency Dephot (1927–32) and an exhibitor in *Film und Foto*, Stuttgart, in 1929. He gave up photography in 1932 and studied painting in Paris before leaving for New York in 1936. This rare later photograph was presumably prompted by the woman working with her washing line, which brings a determined flutter of life to an otherwise unpromising rear window view.

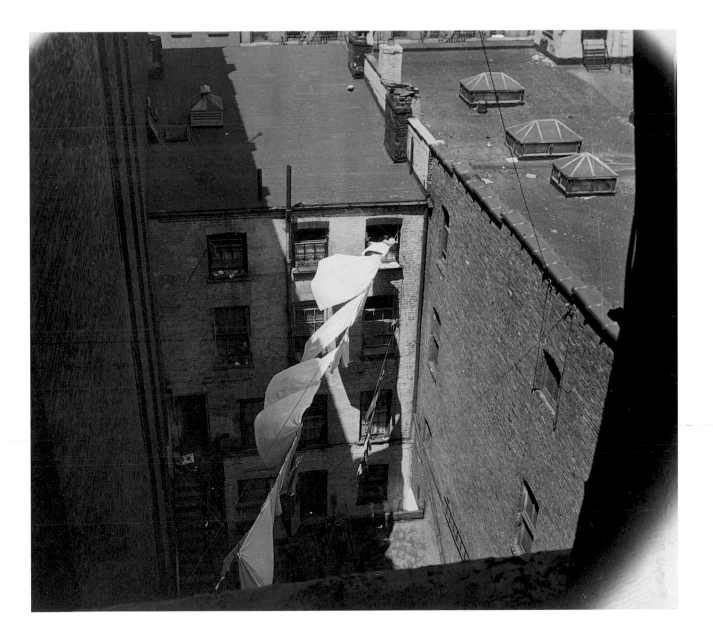

66
Horatio Ross (1801–86)
Dead Stag in Snowy Landscape (c.1858)
Albumen-silver print from wet collodion glass negative

Ross was an expert deerstalker whose exploits included killing
thirteen deer in fourteen shots and eight deer in ten minutes.
He exhibited regularly in the 1850s, allying his photographic
pastime with his deerstalking. His stark view of a kill is
enhanced by the metaphor of a fence trailing away to nothing
and melting snow merging with the swirls of collodion on
his glass plate. In old age Ross doubted the value of his
photographs, consoling himself with the thought that their
accuracy might be helpful to painters. Now his photographs
are shown in galleries again.

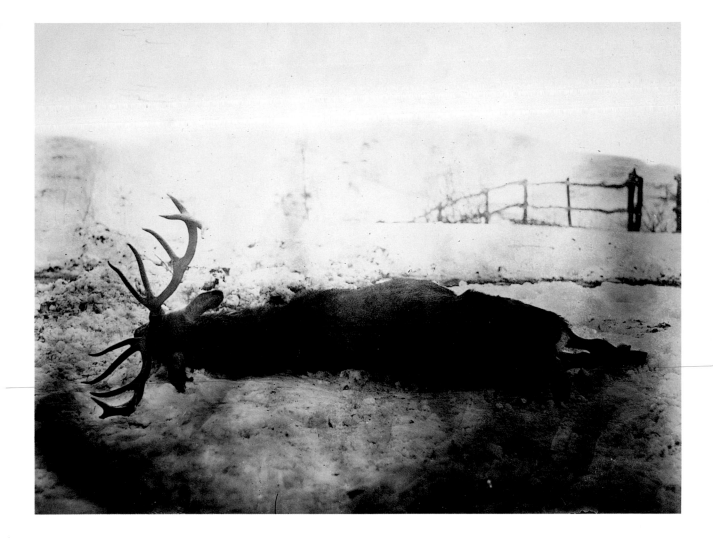

67
André Kertész (1894–1985)
Distortion no. 88 (1933)
Gelatin-silver print

Kertész made hundreds of 'Distortions' in the early 1930s.
The images are straight photographs of reflections of the nude
in a funhouse mirror installed in his Paris studio. They connect
with contemporary works such as the melting watches and other
forms in Dal', the open-form sculptures of Henry Moore, and
paintings by Picasso and Matisse. They also embody qualities
that are characteristic of Kertész as a photographer, from his
beginnings in Budapest to his late career in New York: gaiety,
wit and a childlike joy in appearances.

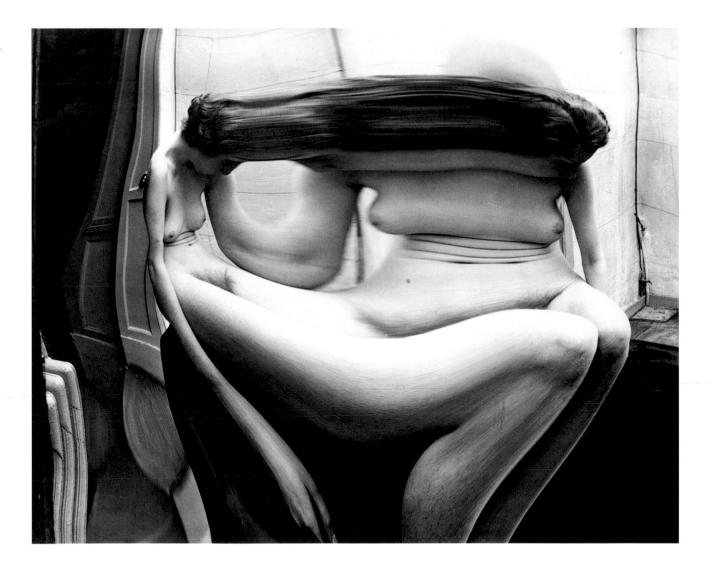

68
Harold Edgerton (1903–90)
Baton twirling (1953)
Gelatin-silver print
Estate stamp on reverse: 85.0925

Attached to the mount is a diagram by Edgerton apparently
giving duration of overall exposure as 60 seconds. In his
stroboscopic photography Edgerton used a controlled pulsing
strobe light – pulsing at speeds as small as a millionth of a
second – in a dark room. This allowed phases of action to be
exposed and superimposed upon each other. He used this
technique to capture the movements of athletes and, here, baton
twirling. He repeated such images tirelessly, not only to analyse
sequential movement but to create an image of calligraphic
elegance and beauty. The 'ghost feet' were a probably
unintentional but amusing addition to the composition.

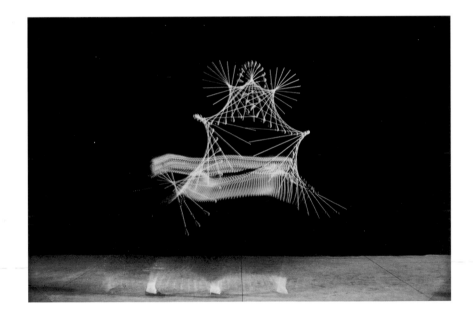

69
Colonel Jean-Charles Langlois (1789–1870) and Léon-Eugène
Mehedin (1828–1905)
Earthen Fortifications, Crimea (1855)
Albumen print from waxed paper negative
Blind stamp on mount: *Martens / Paris*

After fighting in the last Napoleonic campaigns, Langlois became
proprietor of a 360 degree panoramic theatre in Paris, which
offered spectacular illusions of French military conquests. With
Mehedin, an architect, he photographed in the Crimea, where
British, French and Turkish forces defeated Russia. Their
photographs were made as raw material for a panoramic painting
on the war, a colossal view of Sebastopol titled 'The Taking of
the Malakoff' – but are now recognized in their own right as
eloquent, if minimal, images of the desolation of war.

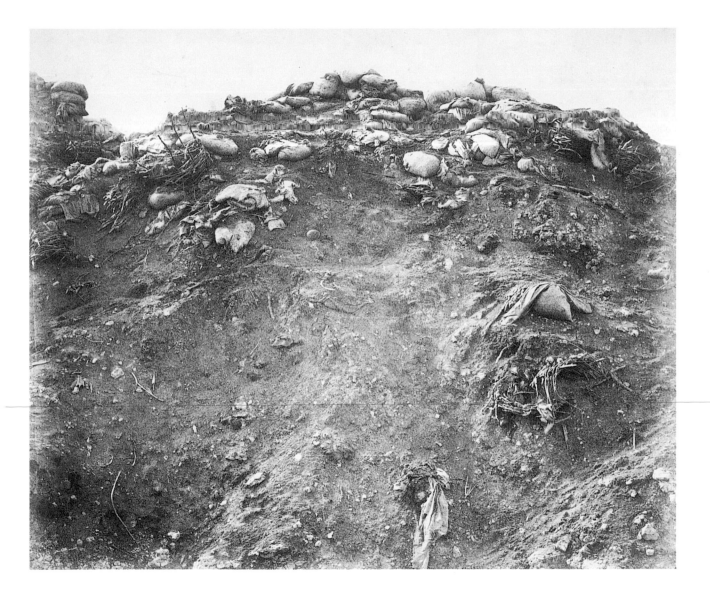

70

David Octavius Hill (1802–70) and Robert Adamson (1821–48)
Jeanie Wilson, Newhaven (1845–6)
Calotype

The Edinburgh partnership of the painter Hill and the chemist
Adamson created not only the best portrait studio in Europe
during the 1840s but also one of the first series of documentary
photographs. They photographed the fishing community of
nearby Newhaven extensively for a publication (never issued)
titled *The Fishermen and Women of the Firth of Forth*. Jeanie Wilson
was one of the stars of the series, described by Elizabeth Rigby
as 'a lovely blooming creature', wearing six petticoats and a
striped butcher's apron 'to wipe her haunds'.

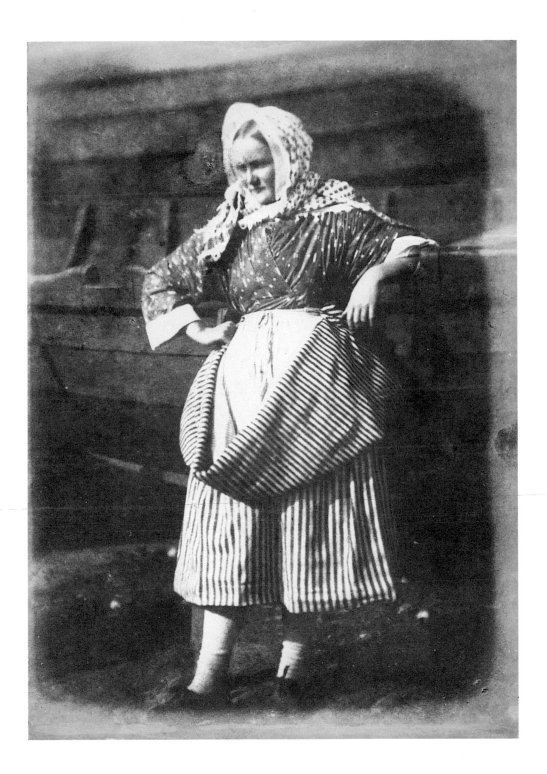

71
Gisèle Freund (b.1912)
Henri Matisse (1948)
C-type print
Inscribed in ink on print: *To James Moores 27.7.98*

Freund fled from Germany to Paris in 1933 and took up the
Leica camera to begin a freelance career as a photographer,
concentrating on portraits of writers and artists. She began
using 35mm colour film as soon as it became available in 1938,
even though magazines in Europe could not yet print in colour.
Freund has said that, compared to writers, artists are easier to
photograph because they 'know, by way of their trade, how to
pose'. Her skill is evident here, where we seem to see the true,
concentrated self of Matisse revealed in the act of drawing.

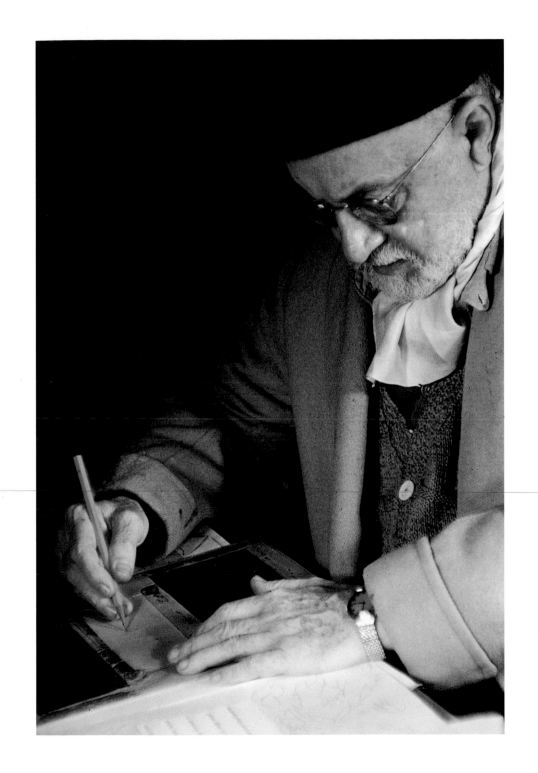

72

Jacques-Henri Lartigue (1894–1986)
A bord du Dahu II, Bibi et Denise Grey (1926)
Gelatin-silver print
Stamped on reverse: *made in 1998 for the Association des Amis de Jacques-Henri Lartigue, Paris*
Blind-stamped on mount: *DONATION J. H. LARTIGUE*

Lartigue became, in the Paris of La Belle Epoque, the world's greatest master of snapshot photography. He was the master in every sense as he achieved his great prowess at the age of seven. However, he did not rest on his laurels but continued making elegant photographs in the 1920s and 1930s and after his rediscovery in the 1960s. This work photographed on board a yacht particularly appealed to Bruce Bernard. He once discussed it with Lartigue, who told him that one of the females on the deck was his wife – but he was not sure which.

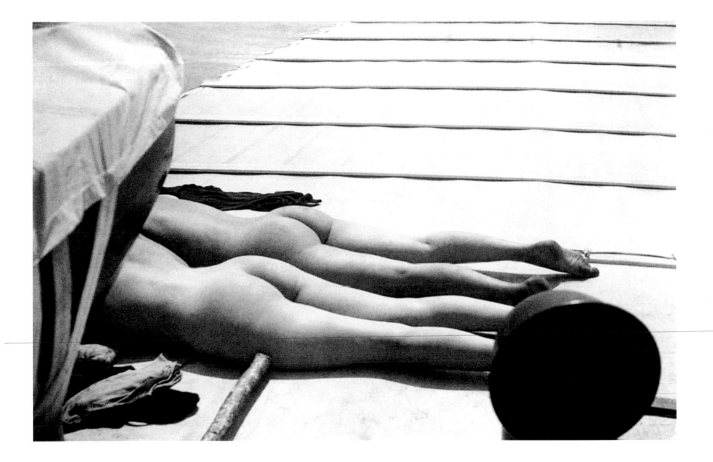

73
Herman Leonard (b.1923)
Billy Holiday, N.Y.C. (1949)
Gelatin-silver print
Signed, titled and dated in ink on the mount

As a young man, beginning to photograph jazz in the late 1940s, Leonard showed great *chutzpah*. He learned about lighting portraits during an apprenticeship with Karsh in Ottawa. Unlike most other jazz photographers, who accepted the constraints of available light, he set up a flash unit on seats close to the stage. Jazz fans have long been grateful that he did. Here he captured 'Lady Day' at the period when alcohol and heroin abuse had diminished her voice but not her talent, which continued to take her audiences into new depths of experience.

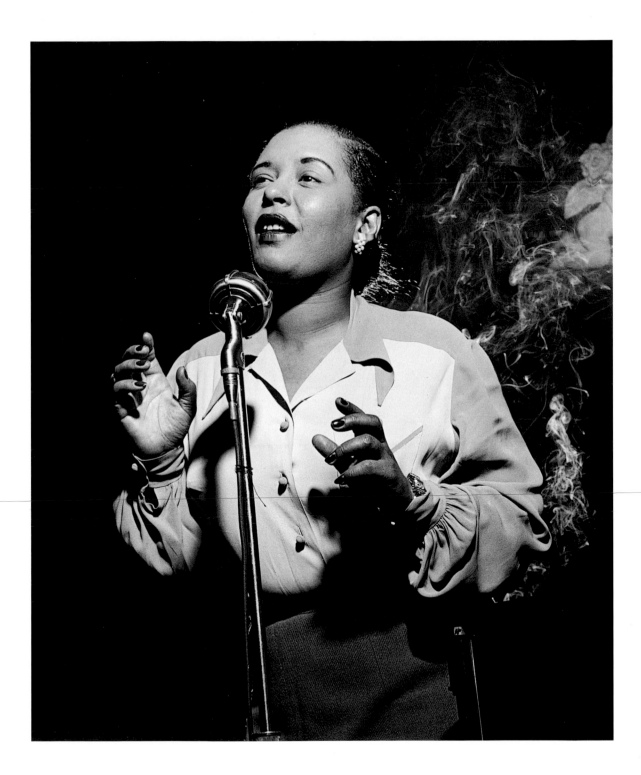

74
Eve Arnold (b.1912)
Marilyn Monroe and Clark Gable on the set of 'The Misfits' (1960)
Gelatin-silver print
Stamped on reverse: Magnum, New York and the John Hillelson
Agency, London

This print was originally supplied by Eve Arnold's agency,
Magnum, and its London representative John Hillelson, for press
use. It was creased and abraded in its working life and shows
the indentations of someone's hastily written words. The
photograph captures a tender moment on a fraught occasion. Eve
Arnold attempted to take usable still photographs on the set of
The Misfits, which was based on a story by Arthur Miller, whom
Monroe was to divorce soon after the shooting was complete.
By then Gable had died of a heart attack. It was also Monroe's
last film; she died in 1962. Despite the stars' embrace, a shadow
threatens from the wall.

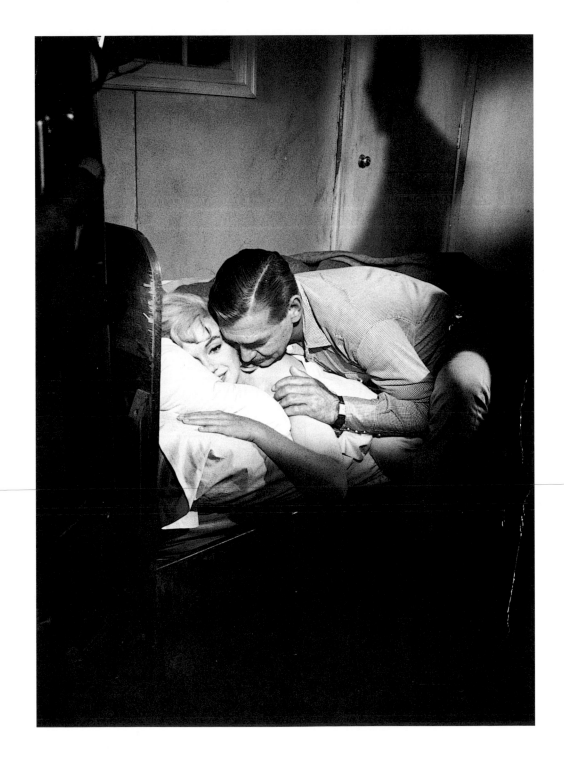

75
Robert Frank (b.1924)
Happening (1961)
Gelatin-silver print
Signed, titled and dated (*1961*) in ink on white border of print
Robert Frank Archive and copyright stamps on reverse

Robert Frank was the photographic poet of the Beat movement,
summed up in his book *The Americans* (1959), and also the
maker of avant-garde films such as *Pull My Daisy*, plus a series
of complex composite works in more recent times. The
'Happening' was Claes Oldenburg's 'Photodeath'. Among those
photographed are Henry Geldzahler (seated left), Tom and
Claire Wesselman and Patterson Sims. According to Oldenburg
(seated at the right), this is the only event of his which Frank
ever photographed.

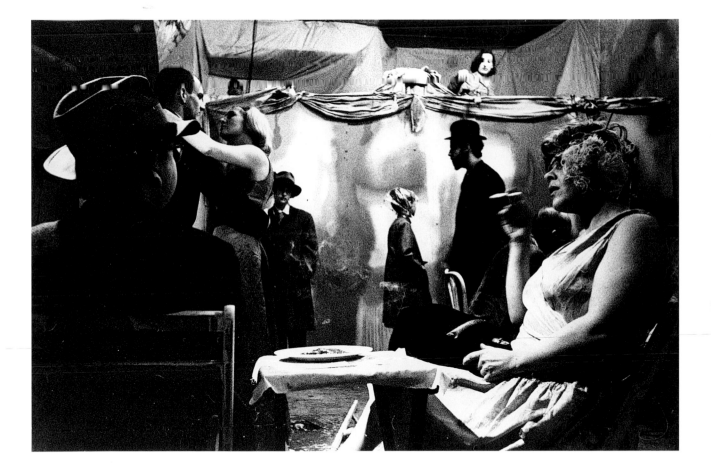

76
Anon
Is My Face Red? (1937).
Gelatin-silver print
Inscribed in pencil on the verso with title and: *Southampton,*
March 12, 1937
Technical data on mount: *5612 35m 1 1/2-6.3 M 2 1/2 M*

The technical data suggest a serious amateur using a relatively
newfangled 35mm camera such as the Leica (introduced in
1925), and using the foreshortening effect offered by a wide-
angle lens to minimize the feet and concentrate attention on the
boy's face. The camera looks down, like a grown-up, on the
grinning boy with his unruly hair, sloping shoulders, falling-off
jacket and niftily-patterned shirt and tie combination. Like most
snapshots, this leaves us in minor suspense.

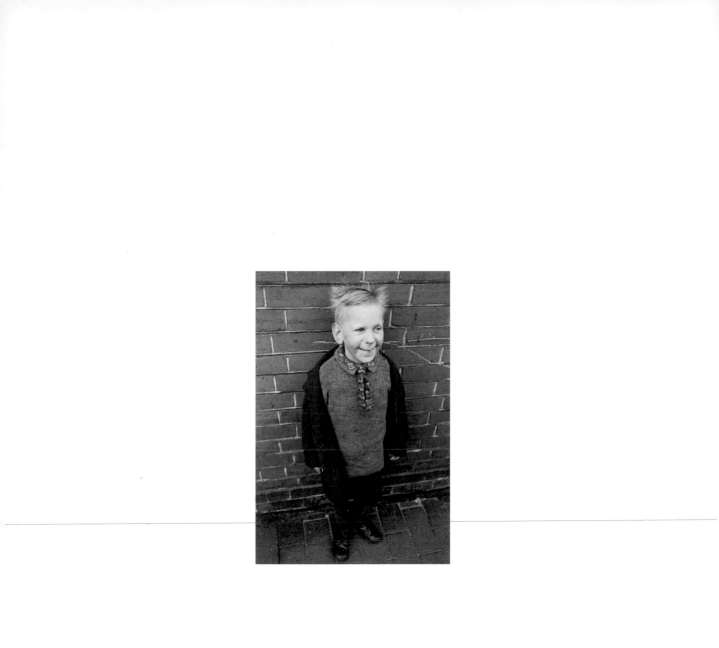

77
Anon
Senior Year Slumber Party (1951)
Gelatin-silver print
Dated in pencil on reverse: *Sept. 1951*

The slumber party has become a midnight swim, in which
bathing caps are worn by most of the girls but swimsuits
apparently by none. Flash obliterates the features of some of the
lovelies and parts of the composition are simply illegible, which
adds pleasantly to the feeling of innocent mischief. The technical
blemishes on this contact print have not prevented someone,
either the photographer or one of the participants, adding
an approving tick – which suggests that there may be an
enlargement or two from this session out there somewhere.

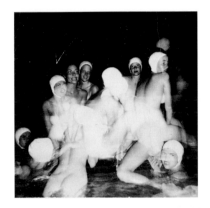

78
Anon
Untitled (1920s)
Gelatin-silver print

It is not clear what this photograph is – a housewife in an apron
slicing something? Or a servant or a cook at work? Artificial
lighting of some kind illuminates the face, but burns out the
nearer hand and throws an attenuated and menacing shadow on
the wall. A casual domestic act begins to look more like a still
from a film that is going to end badly, with that long knife
playing a crucial and bloody role.

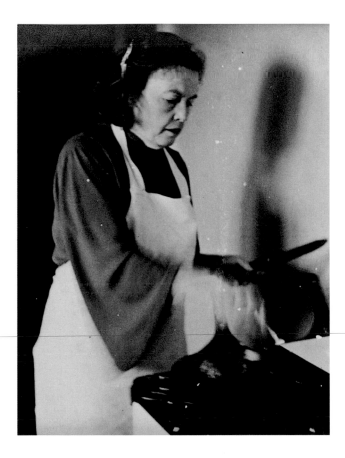

79
Anon
Jack McQuaid. (He joined the navy and is radio man
now on a bomber) (c.1940)
Gelatin-silver print
Titled in ink on reverse

Some professional photographers, such as the roaming
photographer of gypsies Josef Koudelka for example, have made
pictures like this – capturing moments of luxurious ease and
relaxation in an expansive landscape, the walking boots
suggesting a pause to take in the view during an energetic
excursion. This snapshot, of course, is completely changed by
the words written on the back. It becomes an episode in a real
life narrative, and – as it is from an American source – a
glimpse of peace shortly before the US entered the Second
World War in 1941.

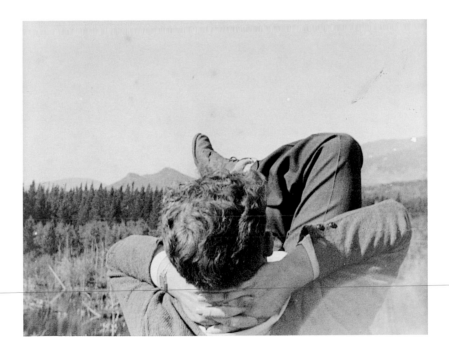

80
Anon
Untitled [Three Children] (c. 1880s)
Hand-coloured tin-type

Tin-types were at the cheap end of portrait photography in the
second half of the nineteenth century and the first half of the
twentieth. They were made on sheets of black enamelled tin-
plate. This is one of the most intriguing examples of the genre.
The portrait group seems to have been composed from two
separate exposures montaged together, with the baby
(photographed nearer the camera) dwarfing his older siblings.
His right hand makes a shape that would have interested Francis
Bacon, as would the paint, which does not match with the
photograph beneath.

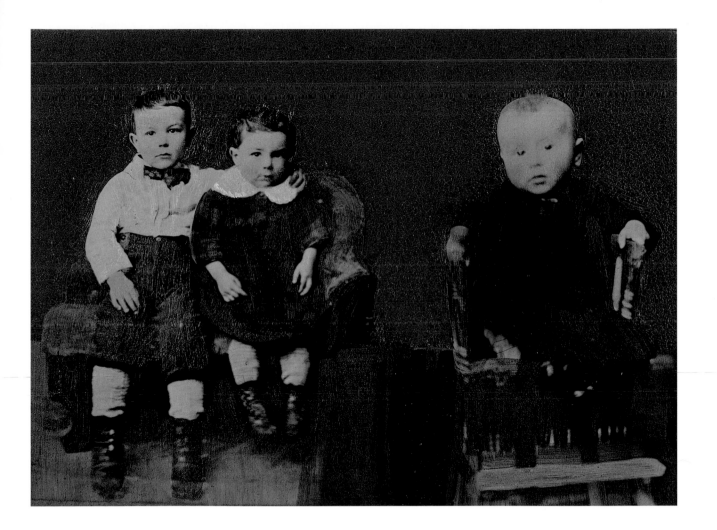

81
Aleksandr Rodchenko (1891–1956)
Fencers at a sports parade (1936)
Gelatin-silver print
Photographer's stamp on reverse

Rodchenko played a major role in Russian Suprematist painting but abandoned his career to become, from 1921 onwards, a leading exponent of Production art or Productivism. This movement sought revolutionary and communal roles for artists. Rodchenko designed propaganda kiosks, posters, book covers, textiles and even sweet papers. Using a Leica camera, he became a poet-propagandist for Soviet magazines. This photograph of athletic Soviet youth, containing at its heart an unexpected black fencer, opens up a new narrative about the USSR in the 1930s.

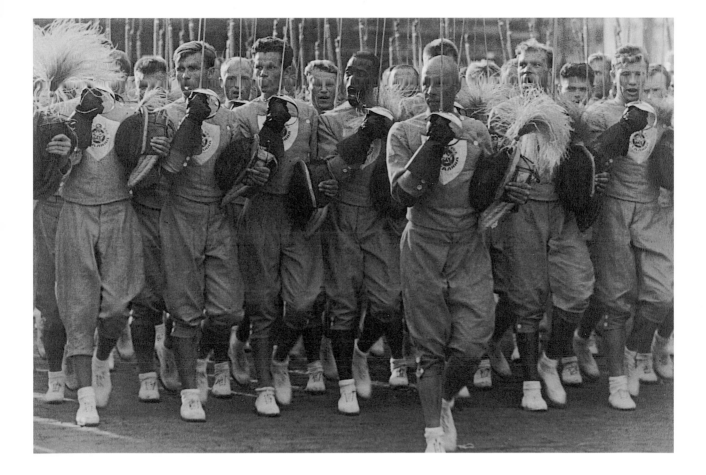

82
John Loengard (b.1934)
Ad Reinhardt Hanging Paintings in his Studio, New York City (1966)
Gelatin-silver print
Signed, titled and dated in pencil on reverse
Photographer's stamp on reverse

Loengard joined *Life* magazine in 1961 and became one of its most prolific contributors, later serving as its picture editor. He is a veteran of many photo-essays, but also a man for the single encapsulating image – as here, when he captured Ad Reinhardt (1913–67) in his studio arranging canvases from his final series, *Abstract Painting, Black* (1960–66). Part of the pleasure of the photograph lies in the contrast between the painter's casual gesture and his cerebral art, but also in the cord which inexplicably hangs in the pristine space.

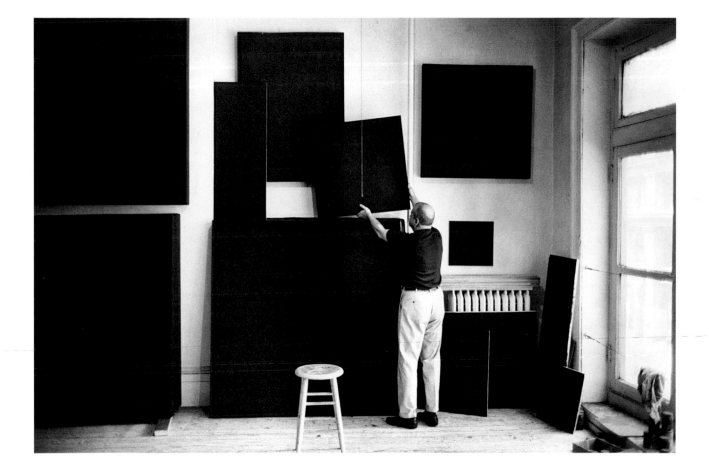

83
Weegee (Arthur Fellig) (1899–1968)
The Duke and Duchess of Windsor at the Circus (1940s)
Gelatin-silver print
Titled in pencil on reverse
Two Weegee stamps on reverse: CREDIT PHOTO BY/WEEGEE/THE
FAMOUS; PLEASE CREDIT/WEEGEE/FROM/PHOTO-REPRESENTATIVES

Weegee played the role of photographic voyeur to the hilt and –
apart from murder and mayhem – he constantly photographed
audiences lost in the spectacle of opera, cinema or the circus.
He was also a tireless photographer of celebrity. Here he brings
the two genres together, taking in the crowd in the more
expensive seats, possibly at Madison Square Garden (one of his
favoured haunts). The abdicated King Edward VIII seems as
absorbed in the act as a child while the duchess remains cannily
expectant of Weegee's flash.

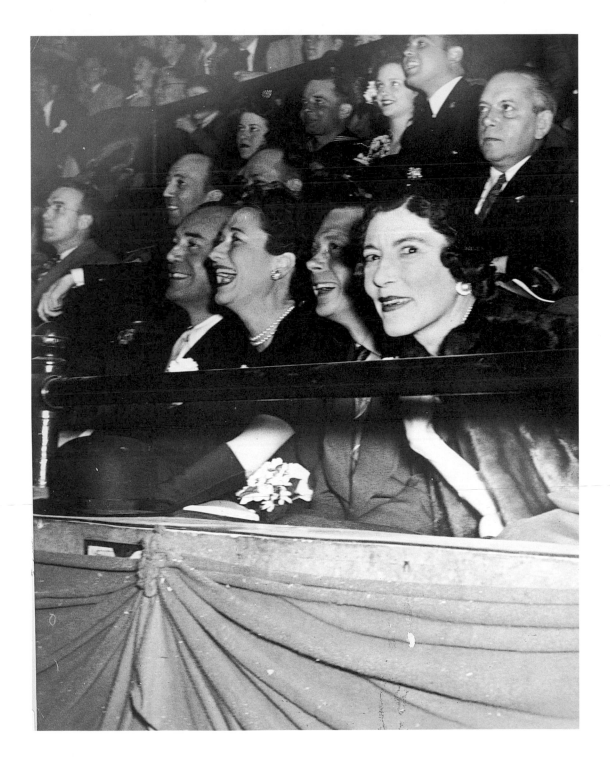

84
Brassaï (1899–1984)
Kiki chantant au Cabaret des Fleurs, Paris (1933)
Gelatin-silver print
Signed and titled in pencil on the reverse
Brassaï's stamp on reverse with Paris address. Signed and titled
in pencil on reverse by Brassaï and inscribed: Vintage.

Brassaï was the master of the flash-bulb, available from 1931,
but Kiki de Montparnasse (born Alice Ernestine Prin in
Burgundy in 1901) was a spectacular subject for any
photographer or writer. Her memoirs, published when she was
twenty-nine, were introduced by Ernest Hemingway: 'She was
very wonderful to look at. Having a fine face to start with she
had made of it a work of art. She had a wonderfully beautiful
body and a fine voice . . . and she certainly dominated that era
of Montparnasse more than Queen Victoria ever dominated the
Victorian era.'

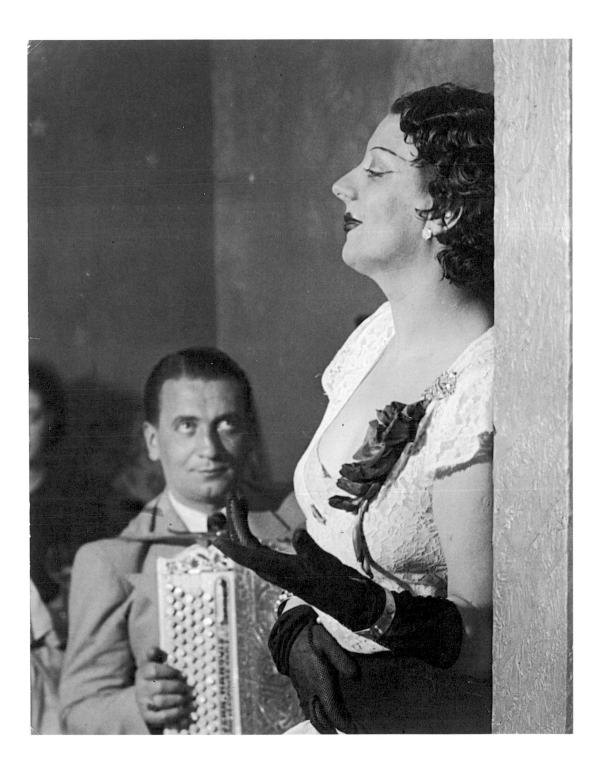

85
Peter Sekaer (1901–50)
Near Voldosta, Georgia, USA (c.1938)
Gelatin-silver print
Signed, titled and dated on reverse by the photographer's wife,
Elisabeth Sekaer Rothschild

American Pictures, a posthumous book of Sekaer's photographs,
recalls *American Photographs* (1938) by Walker Evans. Sekaer
accompanied Evans on a photographic expedition to various
southern states for the New Deal's Resettlement Administration
in 1936. Both believed in the artistic but also the political value
of, in Sekaer's words, 'honest pictures of real people and their
lives'. Some of his photographs are unlike anything by Evans,
including this one of a rudimentary school bus and a distant
figure working high on a telephone pole.

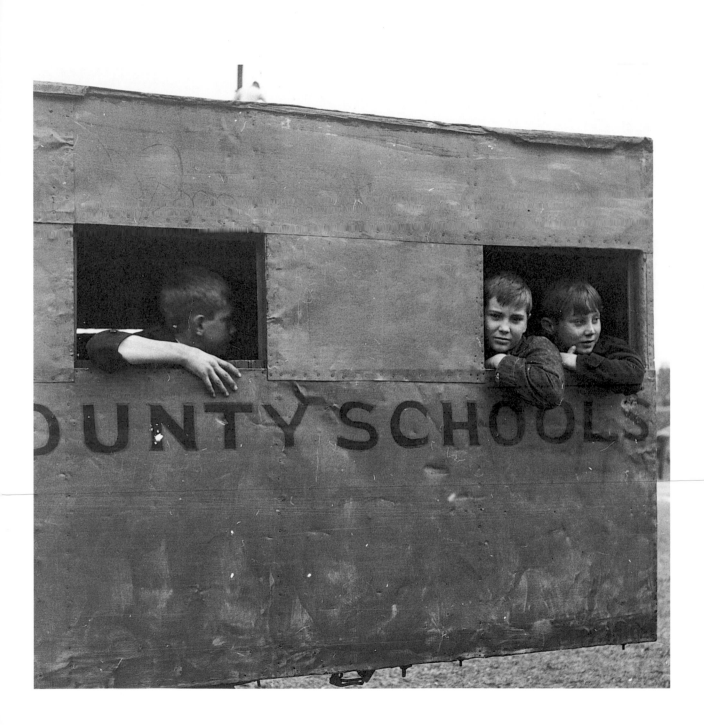

86
Detroit Photographic Co.
Mississippi Cotton Gin at Dahomey (1899)
Photochrome
Titled, credited and lettered: *93415*

Photochromes are photographs printed in colours by lithography. They were widely manufactured and distributed in the 1880s, 1890s and 1900s, mostly for sale to tourists. This is one of the more unusual offerings, an oddly vivid glimpse into the realities of cotton manufacturing. Dahomey in West Africa is now called Benin. The gin was a machine for separating cotton from its seeds. The workers are shown in a factory, every surface of which is festooned, like their clothes, with cotton. An overseer watches menacingly, switch in hand, from the side.

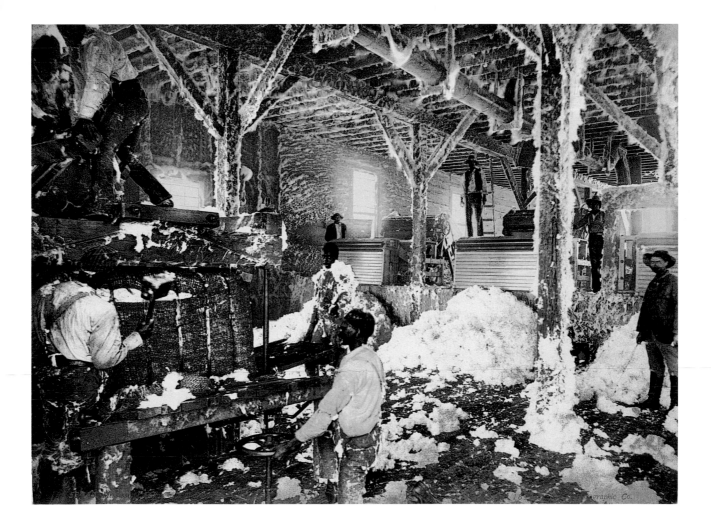

87
Diane Arbus (1923–71)
Woman with a Locket in Washington Square Park, NYC (1965)
Gelatin-silver print
Estate authentication on reverse

Arbus spoke about her photographs better than anyone since: 'You see someone on the street and essentially what you notice about them is the flaw. It's just extraordinary that we should have been given these peculiarities. And, not content with what we were given, we create a whole other set. Our whole guise is like giving a sign to the world to think of us in a certain way.' She speaks of 'we' and 'our', and her vision included not just selected freaks but everyone. No one photographed so well the surface of life and the weight of experience.

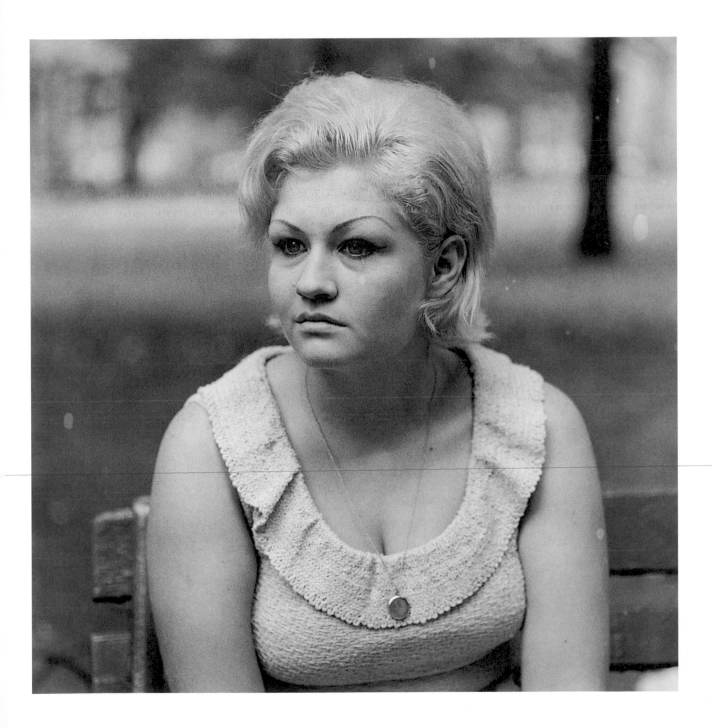

88
Thomas Annan (1829–87)
Saltmarket from Bridgegate (1868)
Carbon print (printed 1878–79)
Printed on mount: *35. Saltmarket, from Bridgegate*

The Glasgow City Improvements Act (1866) was the first
massive municipal intervention to sweep away the most
insanitary and dilapidated and archaic central urban areas and to
replan them on a modern basis. The slums were photographed
by Annan for the Trustees of the Improvements scheme in 1868,
and his series was reissued ten years later in the permanent
carbon process. This photograph is the most animated. The
volatile crowd, partially blurred because of the large plate and
slow exposure, heightens the sense of impending change.

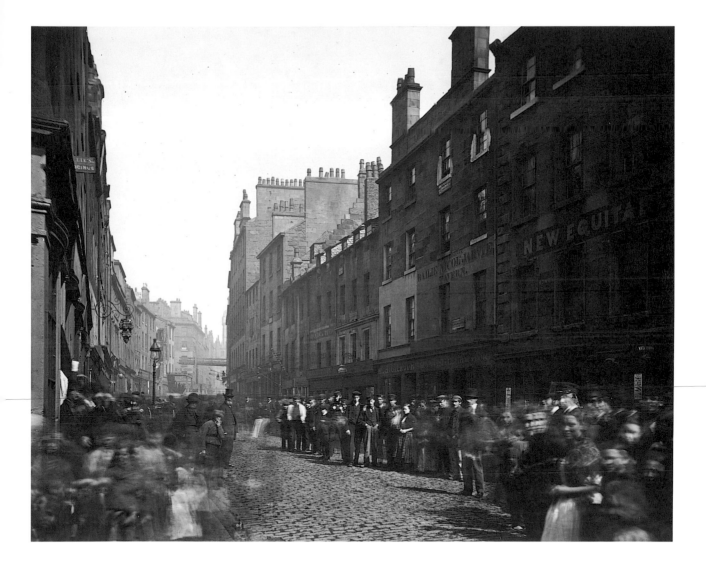

89
Doris Ulmann (1882–1934)
Craftsmen (1925–34)
Gelatin-silver print

This may have been taken as part of Ulmann's extensive project
on *Handicrafts of the Southern Highlands*, of which a selection
appeared in book form in 1937. Although Ulmann photographed
eminent artists, scientists and writers, the core of her work is
from Kentucky, the Carolinas and Virginia. The craftsmen here
appear to be working with wood, and their relaxed postures
suggest that they are engaged on a mutually interesting technical
problem. Ulmann's delicate use of natural light and a soft-focus
lens envelops them in her admiration.

90

Anon

Paris, Fêtes de la Victoire 1918, 14 Juillet (1919)

Gelatin-silver print

Titled in pencil on reverse

Victory at the close of the 1914–18 war was celebrated with
this display centred on the Eiffel Tower on Bastille Day the
following year. The 'City of Light' was illuminated in an
enthralling and moving display. Floodlighting gave some of the
buildings individual prominence and pinpointed different
districts across the city. The photograph captured some parts of
the scene in silhouette, other areas with mid-tones and detail,
and the tower itself as the bright symbol of the city's survival
and triumph.

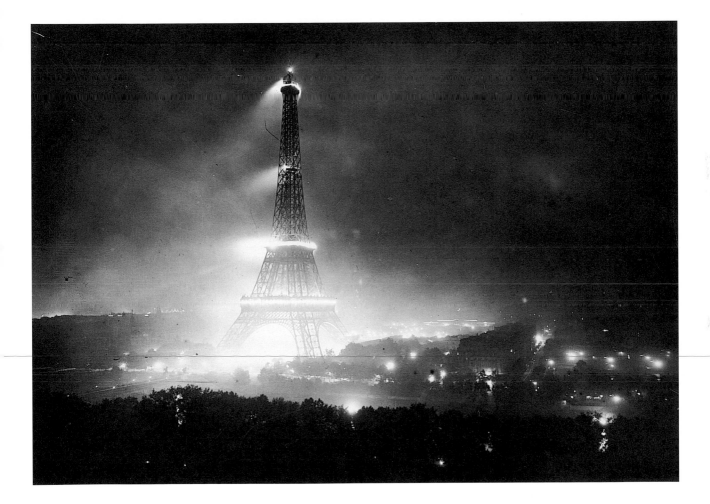

91
Julia Margaret Cameron (1815–79)
She Walks in Beauty (1874)
Albumen-silver print from wet collodion negative

One of Cameron's favourite models was her niece Julia
Jackson, later Mrs Herbert Duckworth, later Mrs Leslie
Stephen. Bruce Bernard wrote of this as 'one of the
photographer's most impressive female portraits – the likeness
of Mrs Duckworth, later the mother of British writer and
painter respectively, Virginia Woolf and Vanessa Bell. The sense
of highly strung nerves that it conveys seems enhanced by
movement blur and her whole demeanour seems one of
absolutely Tennysonian refinement, however Byronic the title
Mrs Cameron chose for it.'

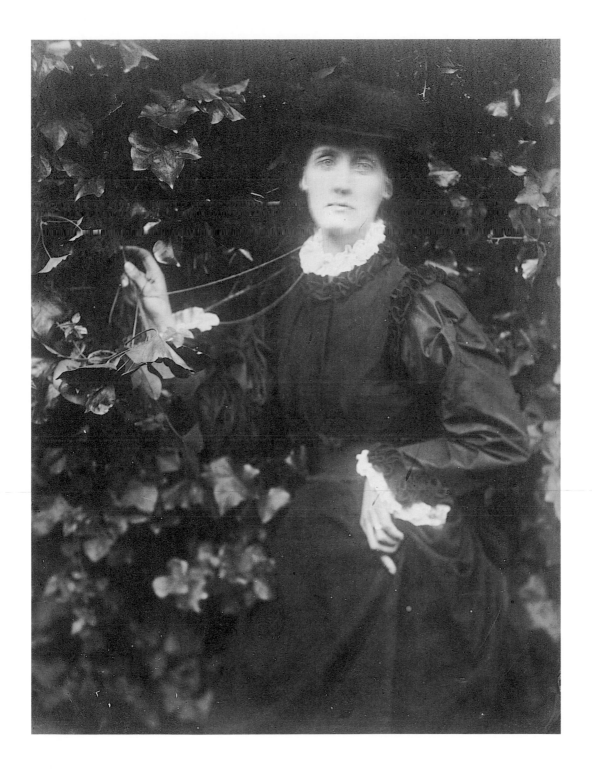

92
William Henry Fox Talbot (1800–77)
The Soliloquy of the Broom (1843)
Calotype

Bruce Bernard wrote of this as 'one of two surviving views of a doorway and a worn broom or besom at Lacock Abbey. Lady Talbot, the great man's mother, called it "The Soliloquy of the Broom". This shot shows far greater contrast and also delicacy in its tones, mass, and the pencil of nature's sharp and linear details of the creepers. It would be satisfying to attribute the faint cloudiness across the doorway to a freshly kindled fire inside the building, but this seems very unlikely. It is the first documentation of any private estate in the world.'

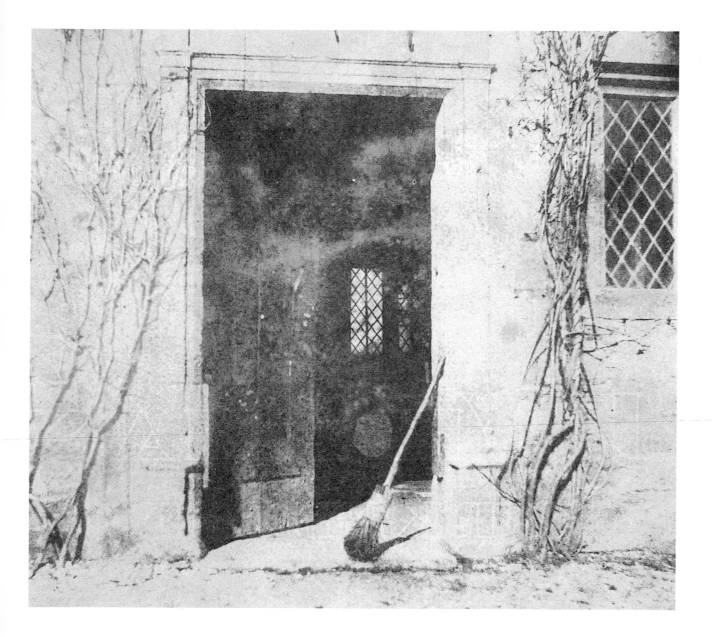

93
William Henry Fox Talbot (1800–77)
Bust of Patroclus (1844)
Calotype

In the early years of the positive/negative photographic process
he invented, Talbot constantly photographed a bust of Patroclus,
a doughty warrior on the Greek side – and companion of
Achilles – in Homer's *Iliad*. Bruce Bernard wrote that 'Talbot
photographed a plaster cast of a Roman bust of Patroclus that
he owned. Like any well observed and lit sculpture it looks at
least as alive in a photograph as it does seen directly by the
eye. Patroclus looks more like a mature general than a young
warrior, but it is both an impressive portrait sculpture
and photograph.'

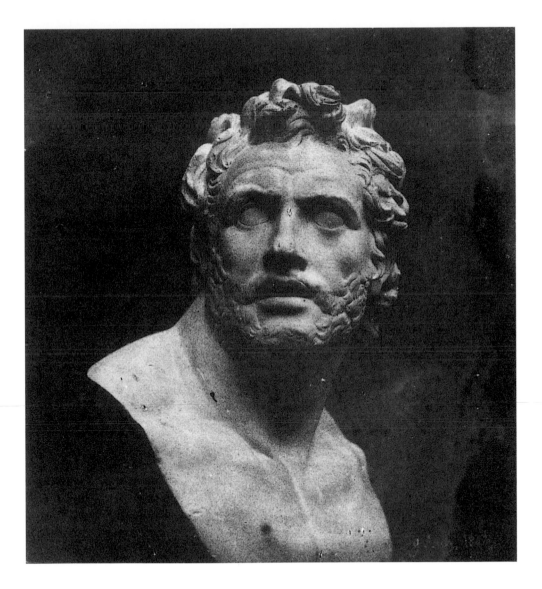

94
Anon
Group of men gathered around a cannon, American Civil War
(1865–67)
Albumen-silver print from glass negative

Photographers documented the Crimean War (1855), the Indian
Mutiny (1857) and the China War (1860), but the American
Civil War was the most extensively and unsparingly
photographed, notably by Mathew Brady and Alexander Gardner.
Many other photographers were involved too, as photographic
studios had sprung up in many parts of the country by the
1860s. This photographer caught very well the nonchalant
demeanour of the soldiers around their gun – while also making
us stare straight into the black hole of its barrel.

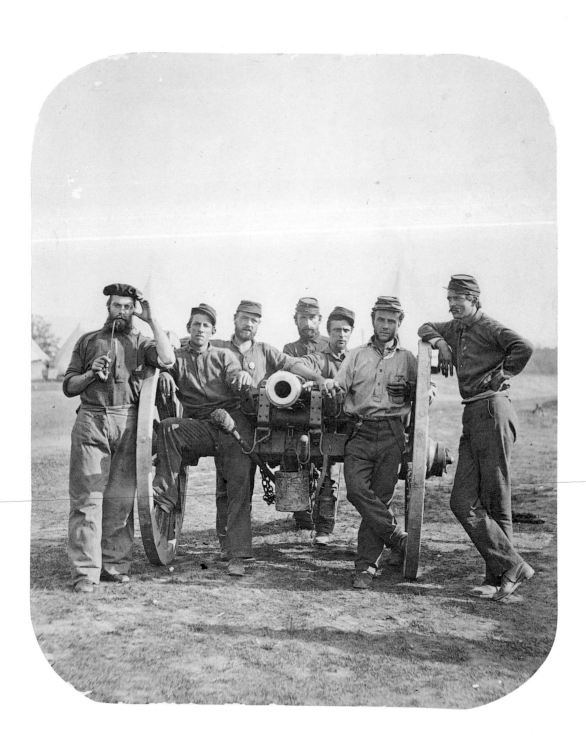

95
Etienne-Jules Marey (1830–1904)
Demonstration de l'accélération dans la chute d'un corps (c.1890)
Celluloid negative (Balagny film)

Marey invented chronography, a technique which enabled him
to capture the movement of objects (as well as the locomotion
of humans and animals), the phases of movement separated by
only fractions of a second. This work ('Demonstration of the
acceleration of a falling object') is part of Marey's celebrated
studies of ballistics and was made at his winter studio in Naples.
His camera was set up with the lens open. In front of the
negative was a disc with ten slots. As the disc rotated the
film was exposed at intervals ten times. An assistant is releasing
a ball and operating the chronograph, which verified the
camera's exposures.

96

Henry Selby Hele-Shaw (1854–1941)
Invisible movements (1901)
Gelatin-silver print

This print (and two others not illustrated here) were originally
in an envelope addressed to Etienne-Jules Marey and may have
belonged to him. They record an experiment by Professor Hele-
Shaw of the University of Liverpool, among whose research
interests was the nature of streamline flow. He introduced planes
of different shapes into tubes of coloured glycerine pressed
between two sheets of glass. Similar studies were illustrated in
La Nature (7 September 1901) under the title 'Des mouvements
invisibles'. Such experiments inspired paintings by the Surrealist
Max Ernst in 1934–5

97
Dorothea Lange (1895–1965)
Women, Thailand (1958)
Gelatin-silver print

Lange is identified with the Farm Security Administration of the
New Deal, for which she photographed in the 1930s, and above
all with one of the most widely reproduced of all photographs,
Migrant Mother, Nipomo, California (1936). However, there were
later chapters to her career, including reportages on the
Japanese-Americans interned in the Second World War, on
Ireland, Egypt, Palestine and the Far East. Here, in contrast
to her most famous work, she created an image (probably by
cropping into a larger negative) of ceremony and abundance.

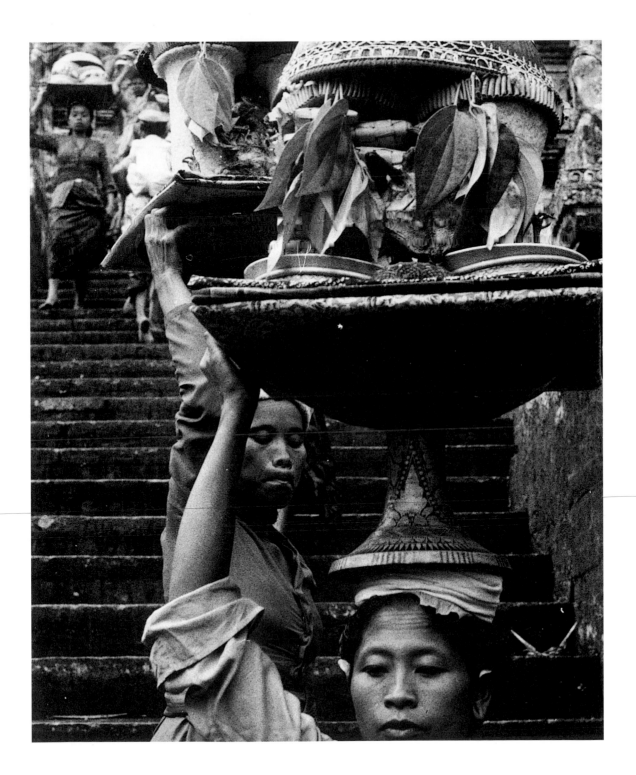

98
Count Olympe Aguado (1827–94)
Vue de Cour de Ferme (1861)
Albumen print from glass negative

Aguado was a serious, wealthy amateur of the 1850s and 1860s.
He invented the *carte de visite* portrait format (see no. 22),
which became a global industry, but did not patent or practise
it. He also photographed urban and suburban leisure, which was
to become Impressionism's great subject. Here he photographed
another favourite motif of the time – the orderly farmyard of a
pious peasantry. Two of the figures in the scene have remained
motionless for the camera – but perhaps one reason why Aguado
made the photograph is the garland decorating the cross.

99
Charles Marville (1816–c.1879)
Trésor de la Cathédrale de Reims (1851)
Salted paper print from paper negative

The first generation of photographers all came from somewhere
else, from other disciplines. Marville was a painter-engraver
turned photographer, one of the first wave whom Nadar called
'the primitives', adding that Marville always remained at heart a
painter. He photographed these reliquaries from the treasury of
the cathedral at Reims with a painter-photographer's eye for the
delicacy of tone and glitter of illumination, and a profound
respect for the mysteries they literally enshrine.

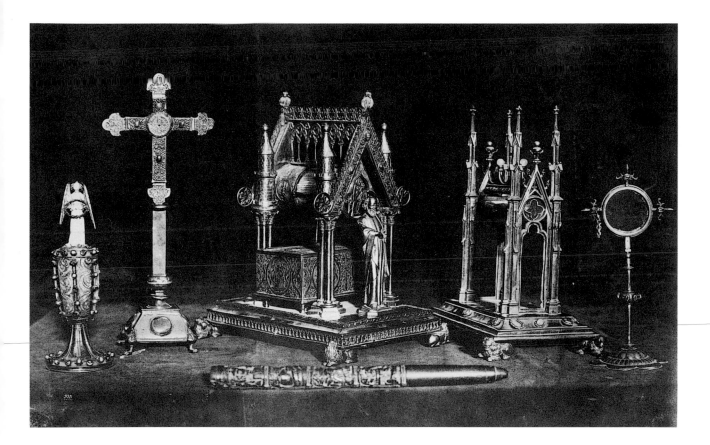

Jean-Baptiste Fremet (1814–89)
Portrait of a Child (c.1855)
Salted paper print from a wet collodion negative
Inscribed: *12*

Fremet, who has only recently been rediscovered as a
photographer, was trained as a painter, spending a brief period
in the studio of Ingres, and becoming a member of l'Ecole
Mystique de Lyon. He fell foul of the Second Empire authorities
in 1852. Fremet photographed family and professional associates
in his garden in Lyon. Here a boy has composed himself to look
steadily into the lens of the camera as if peering forwards into
an uncertain posterity. Bruce Bernard wrote that 'the evocation
of the human presence confers a power on photography before
which all its other capabilities pale.'

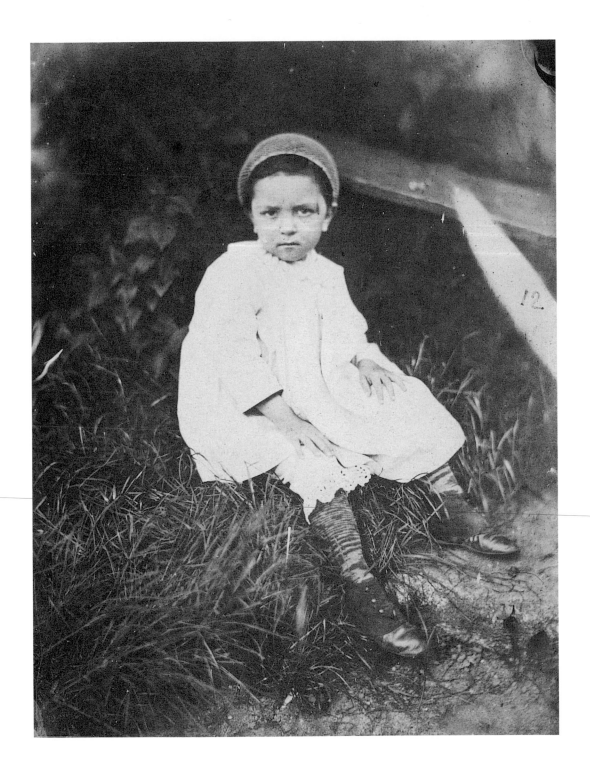

Bruce Bernard
by Mark Haworth-Booth

Bruce Bernard was a picture editor of the highest talent. Do even the best picture editors fall by chance into this unlikely profession? Bruce Bernard was lucky in that he stumbled, after half a lifetime, into a role that turned out to suit him perfectly. He went on to make a formidable contribution to journalism and the painting of his time, but most of all – as a picture editor, writer, photographer and curator – to the art of photography. *100 Photographs* was his final achievement, completed shortly before his death, too soon, in the year 2000.[1] This essay is about the making of the extraordinary eye that informs his farewell book.

Bruce Bernard was born in London in 1928 into a creative and cultured family, from which the children escaped as soon as feasible. His father, Oliver P. Bernard, was a fashionable stage and interior designer. One of his most notable commissions was the Strand Palace Hotel: its foyer, an Art Deco classic of marble, chrome and interior-lit moulded glass, is now owned by the Victoria and Albert Museum. His mother sang and acted as Fedora Roselli. According to family tradition she met Oliver in the London Coliseum in the early 1920s, performing in front of his backdrops. Bruce's brothers also became well-known. The older, Oliver, is an accomplished poet and a highly regarded translator, principally of Rimbaud and Apollinaire. His memoir *Getting Over It* (1992) gives vivid background on his and Bruce's somewhat chaotic wartime schooling and early forays into Soho and Paris. The younger brother, Jeffrey, captivated readers of *The Spectator* with his 'Low Life' column, which later became a highly successful stage play, devised by Keith Waterhouse, starring Peter O'Toole as the columnist. Bruce himself was to become an excellent writer, both as a journalist and the author of many books, but his first and last love was painting.

After education at Bedales School, where he learned – he said later – to be 'anarchic', Bruce resolved to become a painter. On leaving school he opted out of National Service in 1946 as a conscientious objector. Instead, he served as a porter for two years in London hospitals, also attending life classes at St Martin's School of Art. After that he painted in Cornwall from 1948 to 1950, surviving by potato-picking and working in a bakery. Sadly, very few of his drawings and paintings survive. One early painting illustrates the cover of Oliver Bernard's *Verse &c* (2002). The painting is ascribed to Joe Hodges, a name Bruce sometimes used as a pseudonym in later life for articles and occasionally photographs. However, Bruce had – as a schoolboy – already met the painter Lucian Freud. In the Bohemian bars and drinking clubs of Soho in the 1940s and 1950s, he was to get to know many other talents of the London scene – the painters Francis Bacon (in 1948–9), Michael Andrews, Frank Auerbach and the waspish photographer John Deakin all became intimate friends. Oliver Bernard described Soho as 'for me a very

Bruce Bernard, 1992, by Lucian Freud

large and heterogeneous club. I won't say church, though the parallel is there somewhere.'[2] The variety of friendships Bruce made in Soho, embracing many different walks of life, is paralleled by the variety of the photographers and images in this book. However, despite the variousness of his friendships, Bruce was centred on painting and, of course, several of his painter-friends were sophisticated users of photographs. Muriel Belcher's Colony Club was at the heart of his Soho. A typical gathering is recorded in Michael Andrews' large canvas *The Colony Room 1* (1962). Bruce is shown in profile at its centre looking like Rimbaud or an angel. Bruce also appears with his brother Jeffrey and the actor Terry Jones in a Deakin photograph in 1956–7. He was later portrayed in two paintings and an etching by Freud. While Bruce was part of London's artistic élite, he sometimes earned his living on building sites, washing dishes, or, more commonly, scene-shifting in theatres. As he approached forty, Bruce was still a character without a serious role.

It is ironic that the 'part-work' form of publishing should have blossomed in the temperance era, intended as a way of leading the industrious working classes of the mid-nineteenth century to spend their money on improving literature rather than the demon drink. Thanks to improvements in four-colour printing, part-works became dazzlingly successful a century later, in the 1950s and 1960s. The Italian publishers Fratelli Fabbri had shown the way with a series titled 'Knowledge' in the 1950s. This was taken over for publication in Britain by Purnell, to be followed by 'The Masters', a series of some 150 instalments on painting, and then a part-work on the Second World War. Its huge commercial success led Purnell, now an imprint of the British Printing Corporation, to commission an even more ambitious project, a *History of the 20th Century*. Dr John Roberts, an Oxford history don, was appointed General Editor and Germano Facetti chief designer. Martin Heller managed the series for Purnell from offices in Poland Street in Soho.

Born in Italy in 1926, Facetti was one of the liveliest designers of the time. He had recently transformed the look of Penguin Books, where he worked as art director from 1961 to 1972, and was a regular, like Bruce, at the French Pub in Dean Street, Soho. The designer felt that, although Bruce was an often silent companion, who sometimes found communicating difficult (then as later), there was an important bond between them. Facetti recently joked that the fascist school he had had to attend in Italy seemed remarkably similar to some of the various English boarding schools Bruce attended, and that Bruce seemed to have some insight into things Facetti had experienced — most notably his capture by the Germans during the war, followed by two years in a concentration camp. In the later 1960s Facetti was designing sixty Penguin book covers a month and often consulted Bruce informally on illustrations which might have a subtle affinity with the text in hand. Bruce would respond with dozens of well-chosen suggestions.

As the *History of the 20th Century* series gathered pace, Facetti — feeling that Bruce was depressed with his scene-shifting job at the Coliseum — asked if he would lend a hand. The series needed photographs of the crisis in Yugoslavia in 1945. Could Bruce go to Belgrade and bring back whatever he might find? When Bruce asked how he could possibly do such a thing Facetti reminded him that 'his eyes were open to painting' and that he was well-read — he would surely recognize what was important. Bruce was soon on the train and spent Christmas 1968 in Yugoslavia, returning with a suitcase full of photographs and documents culled from state archives, newspapers and individuals. Looking together at the images of executions and deportations, they realized that some photographs of these terrible events were posed reconstructions and others authentic records. It was the beginning of Bruce's education as a picture researcher, a position to which he was soon formally appointed by Martin Heller, and suddenly he blossomed. The *History of the 20th Century* series did too. Apart from its British success, ensured by its snappy design and writing, plus the impressive profusion of photographs, the series was translated into French, Spanish and Japanese and has still been selling in recent times to school and college libraries in the US. Working on the project for the next two and a half years gave Bruce a grounding in picture research, in the ways images function in magazine layouts, and a deepened knowledge of modern history. He knew more hard history than most picture editors and curators. This was demonstrated when we visited an exhibition of Czechoslovakian photography in Prague in 1989. Bruce quickly noted that the Party members who selected it had omitted photographs of modern industries in the 1930s in order to represent the country as basically agrarian before the post-war Communist take-over.

One day in 1971 Bruce received a call from June Stanier, Picture Editor at the *Sunday Times Magazine*. She wondered if he could suggest a source for a particular photograph. Bruce had the very colour transparency on his desk and offered to bring it over himself. When Bruce arrived in the magazine's offices in Gray's Inn Road, Stanier asked him if he might be interested in doing some picture research for the magazine. 'You're only saying that because I brought the tranny over,' Bruce shouted, flinging it down on her desk. It was an interesting start to his ten years at the *Sunday Times Magazine*. He began as a full-time freelance researcher in September 1971, became Picture Editor in March 1974, Picture Editor and Assistant Art Editor in November 1976 and left — after the takeover of Times Newspapers by Rupert Murdoch — in April 1981. During his time at the magazine Bruce worked not only with June Stanier but with the Art Director Michael Rand, the Art Editor David King, and a team

of outstanding photographers, including Ken Griffiths, Don McCullin, David Montgomery and Denis Waugh. He was not the easiest person to be around in an office, June Stanier recalls: he might not speak to a colleague for days, weeks or sometimes a year. She and others persevered because Bruce had not only an endearing gift for friendship but a knack of coming up with the special gems that turned a good feature into something much better. His passion for photography included a certain violence towards anything he considered unambitious or incompetent. Another colleague, Suzanne Hodgart, recalls with horrible vividness how Bruce might behave on returning from lunch at the pub and going through an aspirant's portfolio. 'I don't think I like many of these,' she remembered him saying – adding, 'in fact I don't like *any* of these,' before slamming the portfolio down in disgust. Depending on where his remarks were aimed, Bruce's ability to speak his mind unflinchingly could certainly be exhilarating. However, he was more pussy-cat than polecat and was perfectly professional when I first met him in 1975, to propose a feature on the Victoria & Albert exhibition *The Land: 20th Century Landscape Photographs*, and remained so throughout our twenty-five year association.

Although his career at the magazine involved writing about many painters and photographers, his most sustained series was 'Photodiscovery'. It appeared in the magazine – warmly endorsed by the newspaper's editor, Harold Evans – between 17 September and 29 October 1978. It was published by Thames & Hudson in 1981 as *The Sunday Times Book of Photodiscovery: A Century of Extraordinary Images, 1840–1940*. Despite being in the midst of the highly-pressured magazine world of the 1970s, and at the heart of photojournalism, Bruce was quick to recognize that something unusual was happening to photographic history. This is how he explained it in his preface to the book:

"This book originates in the belated discovery by a photographic editor that the history of photography is much more interesting than he had thought it to be . . . Since I had seen no original nineteenth-century prints of high quality, and because all photographs were reproduced either in black-and-white or a uniform 'sepia', I could not tell what I was missing. I assumed that the unpleasant brown had been happily superseded, rather late in the day, by the more 'real' black-and-white silver bromide print and the colour photograph. I did not realize that economics and the taste and judgement of publishers were concealing something important from me."

Several events threw the switches in his mind. In the course of his work at the magazine, which involved occasional features on historical photography, Bruce saw albums of calotypes by Hill and Adamson and albumen prints by Cameron for the first time. He saw calotypes and photogenic drawings by Talbot at Lacock Abbey. Just as

important, he met Valerie Lloyd, a young curator at the National Portrait Gallery, who showed him the photographic archive of Dr Barnardo's Homes, the British orphanage founded in the 1860s. The Barnardo archive demonstrated to Bruce, he wrote, that 'pictures taken with no artistic motive or intention to impress can be as interesting as any others, and also that the best pictures from such archives are not always selected for anthologies, although most people tend to assume that they have been.' Valerie Lloyd, who moved soon afterwards to the Royal Photographic Society as curator, introduced Bruce to the new breed of collectors who – like Bruce – were avidly discovering and (as it turned out) reconfiguring photographic history. Such New York collectors as Pierre Apraxine of the Gilman Paper Company, Sam Wagstaff and Paul Walter were regular visitors to London for the photographic auctions at Christie's and Sotheby's, which had begun in 1971.

There was already one key publication in the rediscovery of photographic history in the 1970s – John Szarkowski's *Looking at Photographs* (1973, reissued 1999). Something very different came along five years later – Sam Wagstaff's *A Book of Photographs* (1978). It arrived in London with a special cachet. *A Book of Photographs* was exactly that – an extraordinary compilation of photographs, all printed in colour to capture every fugitive nuance of hue, and without a word of historical context, didactic explanation or aesthetic analysis. Wagstaff had already, during his time as a curator at the Wadsworth Atheneum in Hartford, Connecticut, championed Minimalism and Pop. Now his eye embraced, with equal enthusiasm, the diversity of photography – the rare, the classic, the offbeat.[3] His book – more than any other – released photographs from their moorings in photographic history into a post-modern world of free-floating subjective interpretation. The very first photograph – a Frederick Evans platinotype of medieval tombs bearing coats of arms – resonated, loosely but enjoyably, not only with vague memories of crusader knights but with a subtle reminiscence of the target paintings of Kenneth Noland. Wagstaff wrote in his foreword to 'Photodiscovery':

"Bruce Bernard has written a passionate first 'novel' from the raw material of his experience as a photo editor . . . This is not a revisionist history of photography but one man's biased clues as to where the treasure lies – the epicenter of photography – not dedicated to the proposition that all photographs are created equal or unequal, but that many ugly, or beautiful, untouchables have been overlooked in high places."

Whereas *A Book of Photographs* enjoyed a somewhat esoteric success, 'Photodiscovery' had the *Sunday Times* and the publishers Thames & Hudson (and Abrams in New York) behind it. For many photo-maniacs – as Cartier-Bresson calls us – *Photodiscovery* became, like

the publications of Szarkowski and Wagstaff, a holy book.

After leaving the *Sunday Times Magazine* Bruce worked for *The Independent Magazine* (1988–92) as its visual arts consultant. Between times he worked again as a painter for a spell in the 1980s and again in the 1990s drawing with charcoal, destroying both paintings and drawings. He linked up again with Martin Heller, then at Orbis Publishing, producing a series of lavishly illustrated and highly successful books, of which the best-known are *The Bible and its Painters* (1983) and *Vincent by Himself* (1985). He began his curatorial career with *John Deakin: The Salvage of a Photographer* at the Victoria & Albert Museum in 1984. Bruce had found himself in charge of Deakin's photographic legacy after the photographer's death in 1971. The exhibition gave Deakin his proper place in photographic history.[4] Some years afterwards the artist and collector James Moores acquired the Deakin archive from Bruce and in 1996 commissioned him to build this collection. Moores greatly admired Bruce's aesthetic judgement and arranged for him to spend a sum of money annually on buying photographs, plus a generous allowance for travel. With exceptional trust and generosity, he gave Bruce *carte blanche*. Bruce responded with alacrity and panache, regularly attending the auctions in London and New York, the Basel Art Fair, Paris Photo and AIPAD (Association of Independent Photographic Art Dealers) in New York. He constantly visited private dealers and gallerists. I lunched with him at regular intervals at this period, and Bruce would sometimes open his briefcase to reveal his latest discovery or share his doubts about acquiring a work by a big name or for a big price. One of his star finds in *Photodiscovery* made its way into the collection. Bruce first saw the anonymous 1850s ambrotype of the *Veteran of Waterloo with his Wife* when it was sold at Christie's in London in the late 1970s. He reproduced it in the *Sunday Times Magazine* and 'Photodiscovery'. He tracked it down a quarter of a century later and bought it (see no. 27). Many of his choices have roots that lie either in the photographers with whom he worked at the *Sunday Times* or later at the *Independent Magazine* in the early 1990s. His liking for pub photographs and studio photographs is very clear – in the 1990s he was photographing much more frequently himself, with artists and their studios a speciality.[5] More than that, though, is his belief in his own reactions in front of photographs of all kinds, whether by his oldest friends, by those with revered reputations or by those with none.

During the five years in which he built the collection, Bruce was also pulling off a major publication – indeed, one of the greatest *tours de force* in publishing history – *Century* (Phaidon Press, 1999). This astonishing 1,120-page work was the pinnacle of his career, combining his superb eye, his encyclopaedic knowledge of archival sources, and his ability to write pithy and engaging captions. During the same period he contracted the cancer which, despite the treatment he suffered bravely and uncomplainingly, finally took him on 30 March 2000. Before his death he had written the introduction to this book and several of the captions. He had also made a final edit of the collection, bringing it down to exactly one hundred photographs. (Initially, he had hoped to buy about fifty more works.) There were two private showings of the collection in James Moores' London studio in 1998 and 1999. Friends and colleagues were invited to view the collection-in-progress, followed by lunch. At the second of these the fashion designer Bella Freud gave an impromptu speech. She said, before wrapping him in a hug, that she had known Bruce since she was born and had never met anyone with more sensibility and discrimination. James Moores wrote to his curator on 15 November 1999, 'with Deakin and the Collection you have opened a door for me. Photography is much broader country than I had expected. Thank you!'[6]

Notes

1 Valuable obituaries of Bruce Bernard were published by *The Independent* (Ian Jack, 3 April 2000, with additions by Mark Haworth-Booth on 6 April); *The Guardian* (Adrian Searle, 31 March 2000); *The Times* (anonymous, 1 April 2000); *The Daily Telegraph* (Christopher Howse, 31 March 2000), *The Spectator* (Christopher Howse, 8 April 2000). See also Alexander Chancellor, *The Guardian Weekend*, 20 May 2000, p. 7. Bruce Bernard's death was stated as 29 March 2000 in the obituaries but was in fact 30 March.

2 Oliver Bernard, *Getting Over It* (London: Peter Owen, 1992), p. 124.

3 See Weston J. Naef, *The Eye of Sam Wagstaff* (exhibition brochure, Los Angeles: The J. Paul Getty Museum, 1997); Hilton Als, 'Wagstaff's Eye', *The New Yorker* (13 January 1997), pp. 36–43.

4 Other curatorial adventures included *The Art that Threatened Art: Early Photography from the Collection of the Gilman Paper Company* and *A Leap in the Light: 20th Century Photography from the Collection of the Gilman Paper Company*, both with texts by Valerie Lloyd, selected and devised by Bruce Bernard for the South Bank Centre, 1988; *All Human Life*, selected from the Hulton Deutsch (now Hulton Getty) Collection, was curated for the Barbican Art Gallery in 1994.

5 See Paul Moorhouse, *Portraits of Painters: Photographs by Bruce Bernard* (London: Tate Gallery, 2002)

6 I am most grateful to Bruce Bernard's close companion Virginia Verran for her great help in writing this essay and the notes on the photographs, especially for providing me with many insights as well as pertinent documents.

Acknowledgements

My first, and most important, expression of gratitude is to James Moores for commissioning this collection. Bruce Bernard was immensely grateful to him for the opportunity to build this extraordinary group of photographs. It was Bruce's hope that this collection would eventually be published and it has been very rewarding to see this wish fulfilled.

Virginia Verran for the Estate of Bruce Bernard

James Moores would like to thank Virginia Verran for her warm-hearted, constant determination to see this project of Bruce's concluded in accordance with his wishes.

James Moores and Virginia Verran would like to thank everyone who has made this book possible; in particular we wish to thank warmly all the photographers, and their estates, and acknowledge their great individual contribution.

We are indebted to Mark Haworth-Booth, Senior Curator of Photographs at the V&A for the captions he has provided and for his informative and insightful essay. We would like to thank Jane Rankin-Read, James Moores' assistant in the early stages of setting up the collection, who was instrumental in suggesting the possibility of such a venture. Mo Campbell, who succeeded her, was equally devoted to the task and gave enormous support as did Ellen Bigge. Thanks also to Robin Muir for his help with the initial contact with the V&A; Helen Cooper, at the James Moores office; John Riddy for photographing the collection; the photography dealers and galleries, with whom Bruce Bernard built up a strong rapport over many years: Hans P. Kraus, Stephen White, Baudoin Lebon, Deborah Bell, Robert Hershkowitz, Jane Corkin, Jill Quasha, William L. Schaeffer, James Danziger, Howard Greenberg, Paul Kasmin, Kenny Jacobson, Christie's and Sotheby's in London and New York, Lee Marks Fine Arts, Swann Galleries, Robert Miller Gallery, Frith Street Gallery and Banning and Associates, amongst others.

Mark Haworth-Booth warmly thanks the dealers already mentioned and the many photographers among those represented in the collection who kindly helped him on the essay and captions, together with : Martin Barnes, Oliver Bernard, Kate Best, Vladimir Birgus, Dr Marta Braun, Noel Chanan, Zelda Cheatle, Helen Cooper, Charlotte Cotton, Sacha Craddock, Sebastian Dobson, Germano Facetti, Martin Harrison, Martin Heller, Paula Hershkowitz, Suzanne Hodgart, Francis Hodgson, Graham Howe, Susan Lambert, Catherine Lampert, Michael Mack, Roger Malbert, Rebecca McLelland (*The Sunday Times Magazine*), Ian Mac Donald, Professor David Alan Mellor, John Meriton, David Montgomery, Janet Skidmore, June Stanier, Lindsey Stewart, Virginia Zabriskie.

Photographic credits

Mario Algaze, represented by Throgmorton Fine Art, New York: p.41; courtesy Eve Arnold: p.151; Copyright © 1972 The Estate of Diane Arbus, LLC: p.177; courtesy of Marco Bischof: p.63; courtesy Madame G Brassaï: p.171; © The Estate of Harry Callahan, courtesy Pace/MacGill Gallery, New York: p.95; © Ervina Boková-Drtiklová: p.55; courtesy Harry Diamond: p.31; © Harold and Esther Edgerton Foundation, 2002, courtesy of Palm Press, Inc.: p.139; © Mark Faurer, courtesy Howard Greenberg Gallery: p. 99; courtesy Eugene J Prakapas: p.133; © Robert Frank, courtesy Pace/MacGill Gallery, New York: p.153; courtesy Agency Nina Beskow: p.145; courtesy Ken Griffiths: p.59; courtesy Evelyn Hofer: p.51; © 2002 E O Hoppé Trust, c/o Curatorial Assistance, Inc., Los Angeles: p.91, p.113; courtesy Colin Jones: p.25; Photo A. Kertész © Ministère de la Culture – France: p.137; courtesy David King: p.7; courtesy William Klein: p.77; Photograph by Jacques Henri Lartigue © Ministère de la Culture – France/AAJHL: p.147; courtesy Peter Lavery: p.69; courtesy Herman Leonard Photography LLC: p.149; courtesy John Loengard: p.167; courtesy Roger Mayne: p.127; courtesy Don McCullin: p.109; Copyright © Gösta Peterson/Courtesy Deborah Bell Photographs, New York: p.75; courtesy John Riddy: p.131; courtesy of Howard Schinkler Fine Art: p.165; courtesy The Peter Sekaer Estate: p.173; courtesy Getty Images/Hulton Archive/Weegee: p67; courtesy Patricia and Nina Wise: p.23. All images © the photographers, unless otherwise stated.
All reasonable efforts have been made to trace copyright holders of photographs. We apologise to any that we have not been able to trace.

Phaidon Press Limited
Regent's Wharf
All Saints Street
London N1 9PA

Phaidon Press Inc.
180 Varick Street
New York, NY 10014

www.phaidon.com

First published 2002
© 2002 Phaidon Press Limited

ISBN 0 7148 4278-8

A CIP catalogue record is available for this book from the British Library.

Designed by Karl Shanahan
Printed in Hong Kong

TR
650
.B47
2002

DATE DUE